Zion National Park

impressions

photography by **James Randklev** & **Tom Till**

foreword by **Lyman Hafen** • text by **Greer K. Chesher**

FARCOUNTRY
PRESS

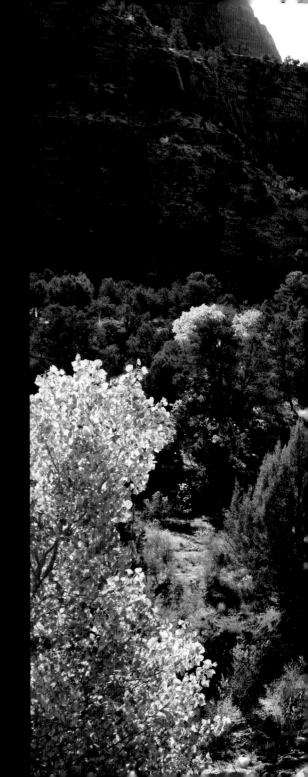

Right: On a crisp fall day, The Watchman guards the mouth of Zion Canyon. JAMES RANDKLEV

Below: Long-eared owl. TOM TILL

Title page: The Virgin River courses through the Narrows near the Mountain of Mystery, creating a spectacular sandstone cathedral. JAMES RANDKLEV

Cover: A summer sunset illuminates The Watchman and Johnson Mountain. TOM TILL

Back cover: Bigtooth maples frame a Middle Emerald Pool waterfall. JAMES RANDKLEV

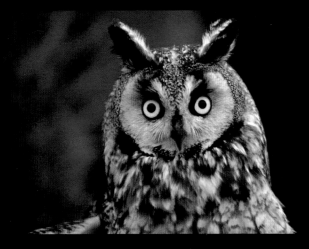

ISBN: 978-1-56037-431-2

© 2008 by Farcountry Press
Photography © 2008 by James Randklev and Tom Till

For more information about our books, write Farcountry Press, P.O. Box 5630, Helena, MT 59604; call (800) 821-3874; or visit www.farcountrypress.com.

Produced and printed in the United States of America.

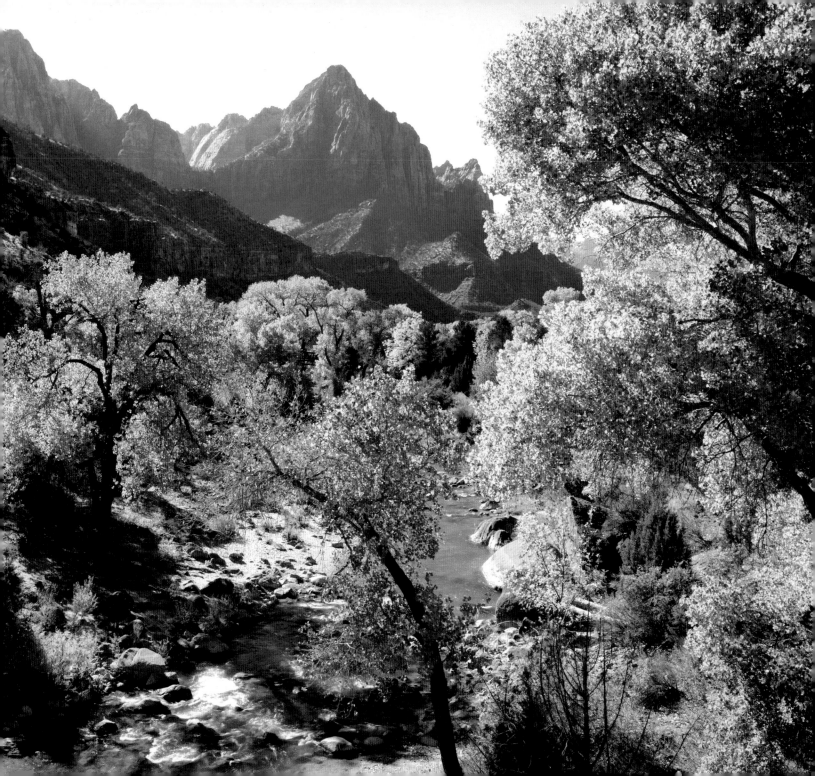

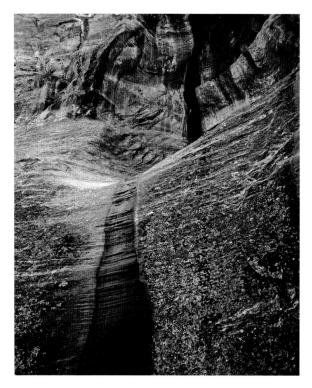

Sandstone alcove with water seep, Kolob Canyons. JAMES RANDKLEV

FOREWORD

by Lyman Hafen

executive director
Zion Natural History Association

In the summer of 1903, Frederick S. Dellenbaugh visited Zion Canyon. It was a trip he had wanted to make for thirty years.

As a young man fresh out of school, he had accompanied John Wesley Powell on his second expedition of the Colorado River in the early 1870s and had followed the legendary explorer around the Colorado Plateau as a topographer and chart maker.

From several angles, and at long distances, he had viewed the great temples of Zion looming on the horizon. But the opportunity for a closer look did not present itself. For three decades he dreamed of coming back to explore the canyon whose mystery had exerted a tight grip on his imagination.

During that interim Dellenbaugh traveled throughout Europe and trained as an artist. When he finally returned to southern Utah in 1903, he was well prepared to write about it, photograph it, and paint it. Frederick Dellenbaugh's sojourn in southern Utah was by horse-drawn covered wagon. He was welcomed by Oliver D. Gifford, the Mormon bishop in Springdale, and was invited to camp on his property near what is now the town's post office.

Dellenbaugh made a multiday foray into the canyon, taking photographs and making notes that would end up in the January 1904 edition of *Scribner's Magazine*. His article, titled "A New Valley of Wonders," filled seventeen pages in what was one of the most popular periodicals in America at the time. His story was something like what the Travel Channel would feature on TV today. For the first time, multitudes of Americans were introduced to what Dellenbaugh called "a wondrous expanse of magnificent precipices."

The man had been thoroughly seduced by Zion. He reached deep into his bounteous store of descriptive terms to express his awe. "To the eye prejudiced by the soft blues and grays of a familiar Eastern United States or European district," he wrote, "this immense prodigality of color is startling, perhaps painful; it seems to the inflexible mind unwarranted, immodest, as if Nature had stripped and posed nude, unblushing before humanity."

The colors of Zion Canyon caused Dellenbaugh's heart, and rhetoric, to soar. Unfortunately, except through his florid prose, color was the only thing he could not reproduce in his *Scribner's* article. Magazines of the day were printed in black and white. So although his photos documented the towering majesty of Zion, they could not convey the canyon's "immense prodigality of color." For that, Dellenbaugh turned to his canvas and oil paints.

He completed several paintings of Zion Canyon in time to exhibit them in the 1904 World's Fair in St. Louis. During the exhibition, a young man named David Hirschi, who had grown up in the village of Rockville at the mouth of Zion Canyon, happened through St. Louis on his way home to southern Utah. Hirschi was delighted to discover a Utah pavilion featuring paintings of his old stomping grounds.

As Hirschi entered the exhibition, he was taken aback by the incredulity of the people viewing the paintings. It seems the folks were quite suspicious of this Dellenbaugh chap. They thought he was trying to pull a fast one on them. They could not believe a place so resplendently magnificent, so plastered with color, actually existed

on earth. These were people who saw the world in black and white, through the pages of periodicals like *Scribner's*. They were "prejudiced by the soft blues and grays" of the East and of Europe. They did not believe what they were seeing.

Young Hirschi went about the exhibition trying, one-on-one, to convince the fair-goers that Dellenbaugh's images were in fact almost exact representations of a place he knew well. Finally he got up on a soap box and called the gathering to attention. He told them there honestly was a place called Zion Canyon, a landscape of unmatched beauty. He assured them that Mr. Dellenbaugh's paintings were true representations of that place. To anyone who doubted, he lifted his shoe and pointed to its buckskin laces. "I made the laces in this shoe from a deer I shot on that hill," he said, and he pointed to a spot in one of the paintings.

Dellenbaugh's *Scribner's* article, and his oil paintings in the 1904 World's Fair, played an important role in the process that led to President William Howard Taft's designation of Zion Canyon as Mukuntuweap National Monument in 1909. Ten years later the canyon officially became Zion National Park.

In this day and age we are bombarded by color images in such proliferation it is easy to become complacent to their beauty. But as James Randklev and Tom Till have proven in the pages of this book, the utter magnificence of Zion National Park can still stop you in your tracks and cause you to wonder if such a place truly exists. As one who comes to work in the canyon every day, I can assure you it does exist, just as these two wonderful artists have captured it—just as Frederick Dellenbaugh described his first view of Zion's West Temple in his *Scribner's* article more than a century ago:

> Without a shred of disguise its transcendent form
> rises preeminent. There is almost nothing to compare
> to it. Niagara has the beauty of energy; the Grand
> Canyon of immensity; the Yellowstone of singularity;
> the Yosemite of altitude; the ocean of power; this
> Great Temple of eternity.

The view from Angels Landing reveals the massive Navajo Sandstone cliffs that define Zion Canyon. JAMES RANDKLEV

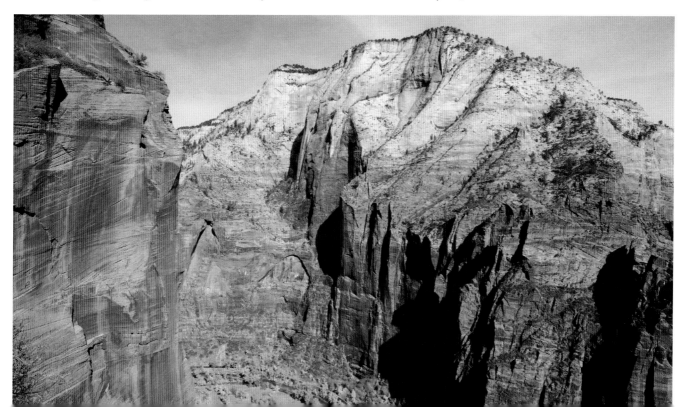

Right: Water springing from rock adds to the current that carves Zion Canyon. The huge Navajo Sandstone formed when a massive desert—like the modern Sahara—covered parts of Utah, Colorado, Wyoming, and New Mexico. TOM TILL

Far right: Zion's story begins in the sands of a wind-blown desert and ends with water's long-missed touch. Almost everything one sees in Zion Canyon is the result of forces on the move. Two hundred fifty million years ago, relentless desert winds piled sand thousands of feet thick. Today, water's unstoppable downhill journey carves canyons. Here, North Creek, cascading from high elevation to low, cuts Left Fork Canyon. TOM TILL

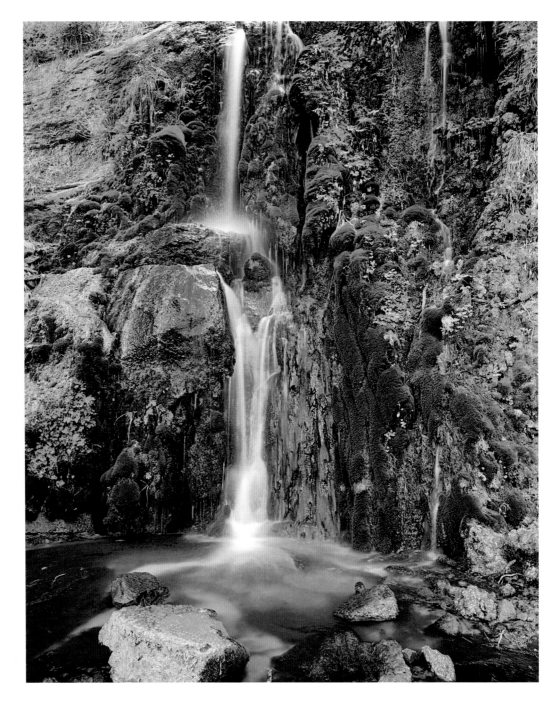

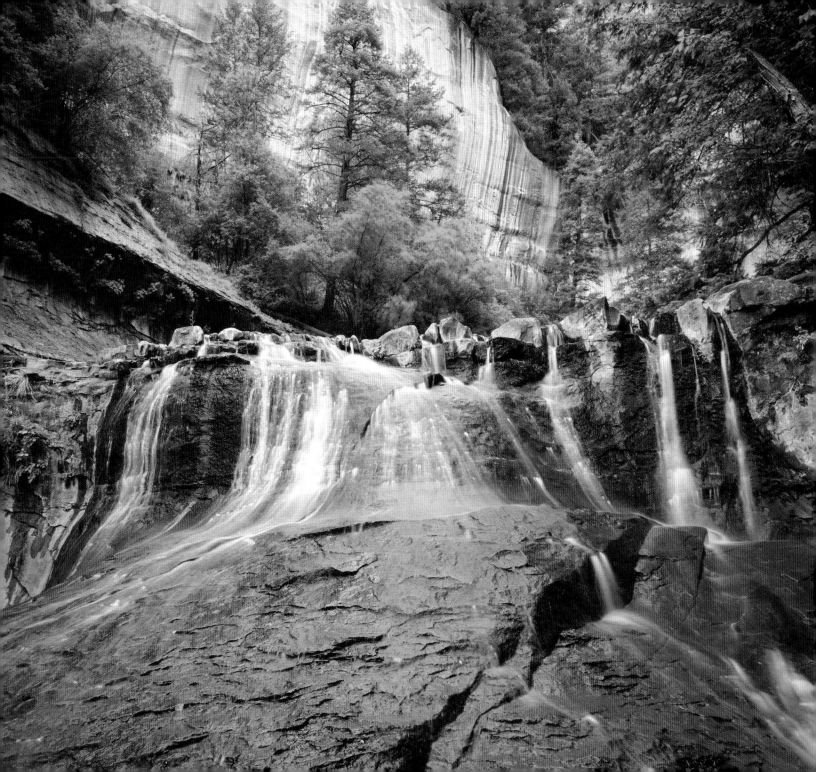

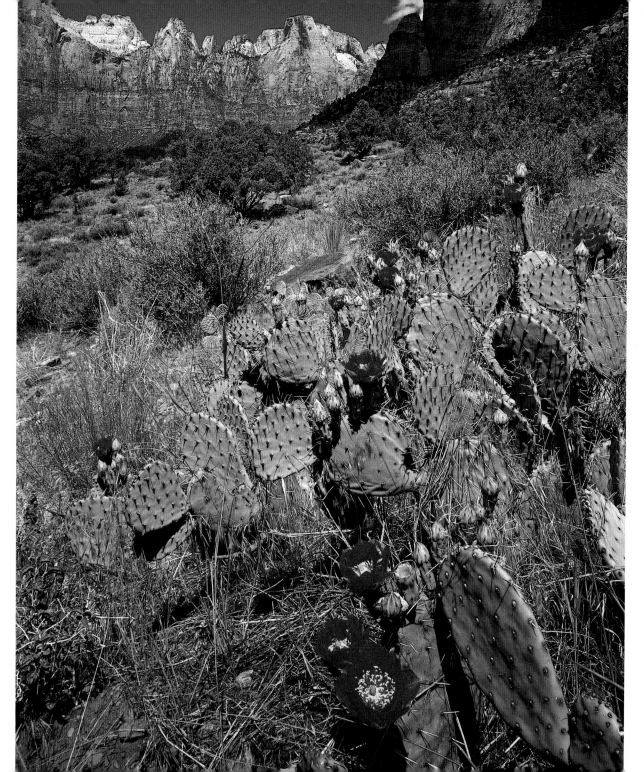

Away from the Virgin River, dry slopes sprout plants more typical of desert environments. This red-flowering prickly pear cactus has had a good year—its pads are turgid with water. In the background the magnificent Temples and Towers of the Virgin rise. TOM TILL

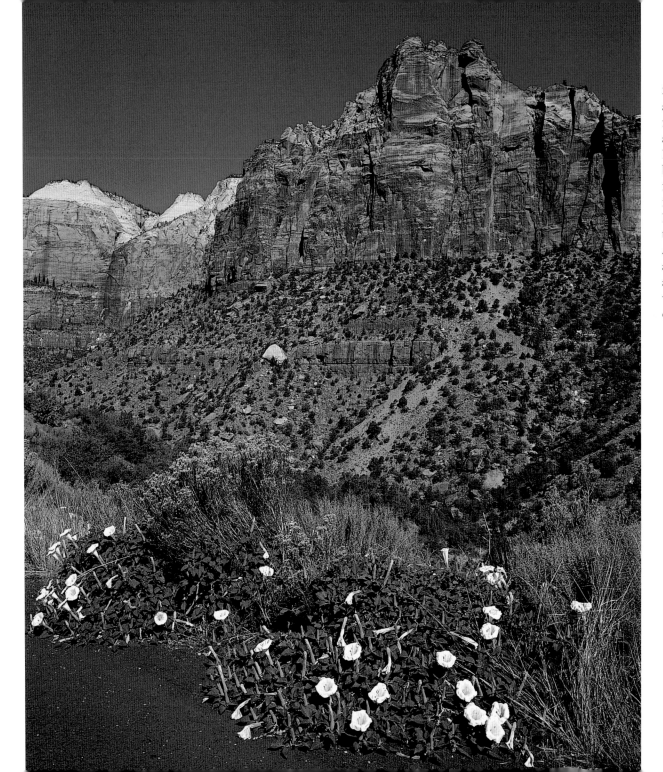

Sacred datura, another desert native, blooms above Pine Creek. Because datura blooms at night, it is often called moon flower or moon lily. By early afternoon the flowers fade. Although beautiful, all parts of datura, also called jimsonweed, are poisonous. JAMES RANDKLEV

9

Right: The Virgin River runs wall to wall in the slimmest section of the famous Narrows. Here, Zion Canyon is only thirty feet wide; seven miles downstream near the visitor center, the canyon's width grows to a half mile. TOM TILL

Below: The vertical walls of the Narrows widen as the Virgin River cuts into the underlying Kayenta Shale, a softer, more easily eroded rock. JAMES RANDKLEV

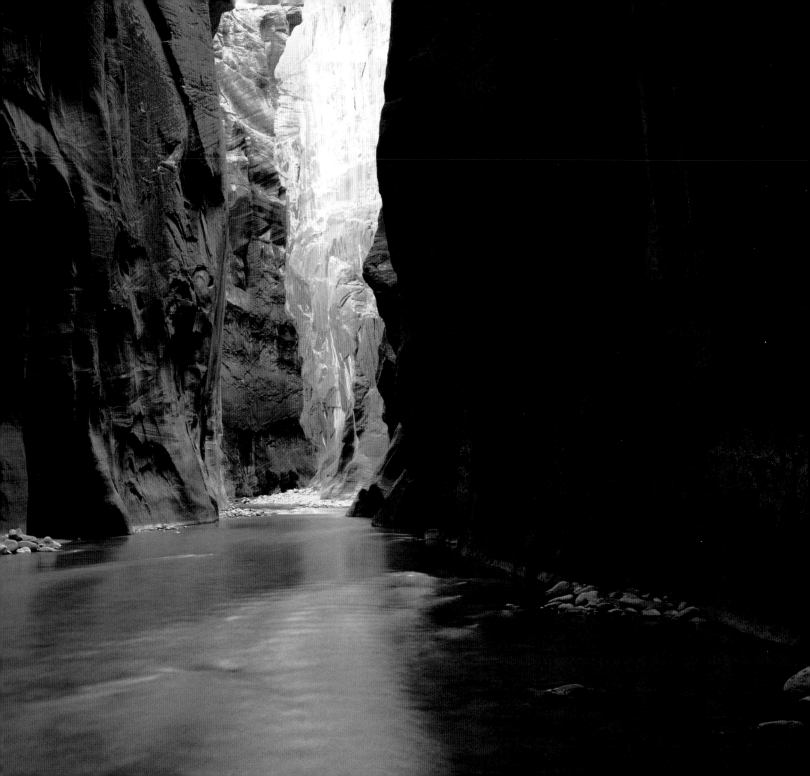

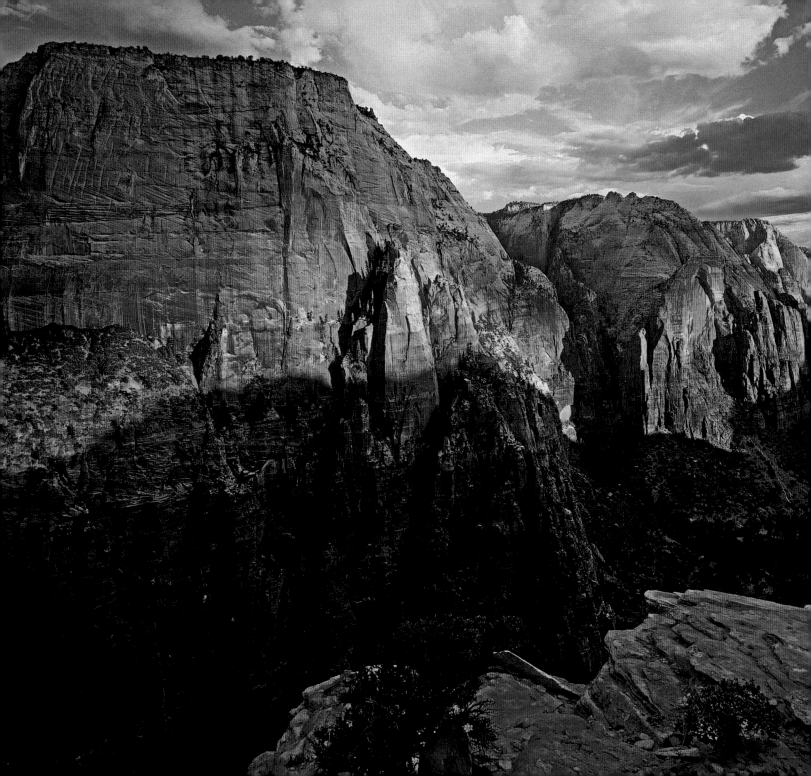

Left: Zion Canyon's east wall glows at sunset. The canyon continues to widen downstream as the Virgin River, working its way into the softer Kayenta Shale, undermines towering sandstone walls. TOM TILL

Below: Golden buckwheat blooms under the seeming immutability of the Kolob Finger Canyons. TOM TILL

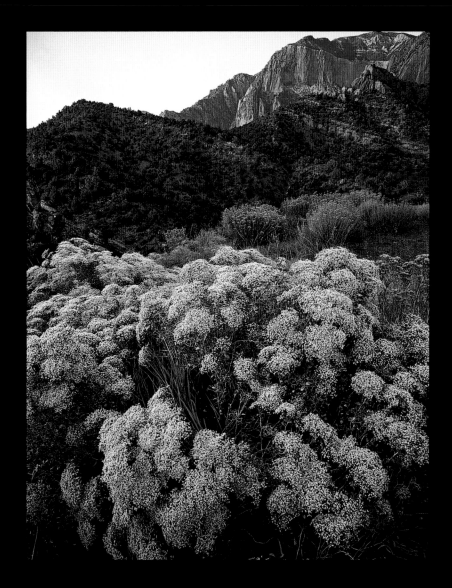

Right: People ancestral to modern Pueblo Indians, whom many call Anasazi, are believed to have planted the Virgin River floodplains with corn, beans, melons, and squash more than 800 years ago. The river's yearly floods replenished the soil and fertilized crops. Next year's seeds were tucked high above in tight-walled granaries, away from the ruinous reach of water and nosy critters. TOM TILL

Below: Water leaves ripple marks in mud, echoing the cross-bedded, wind-blown undulations frozen in Navajo Sandstone. JAMES RANDKLEV

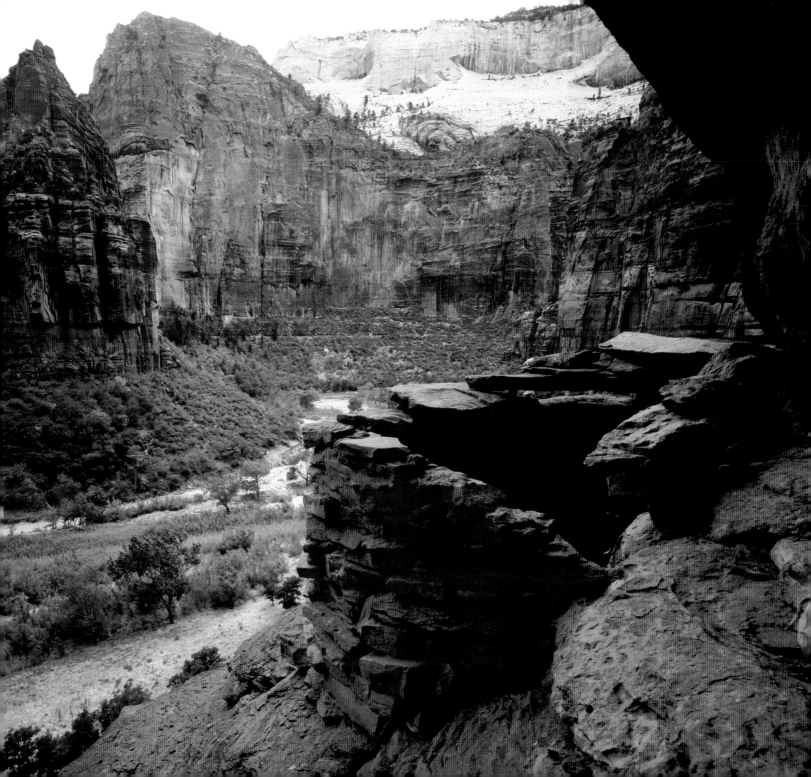

Water cascading through Orderville Canyon to join the Virgin River's North Fork forms a refreshing waterfall over a sand-stone ledge. Eventually the ledge will erode, and this delightful water hop will wear smooth. TOM TILL

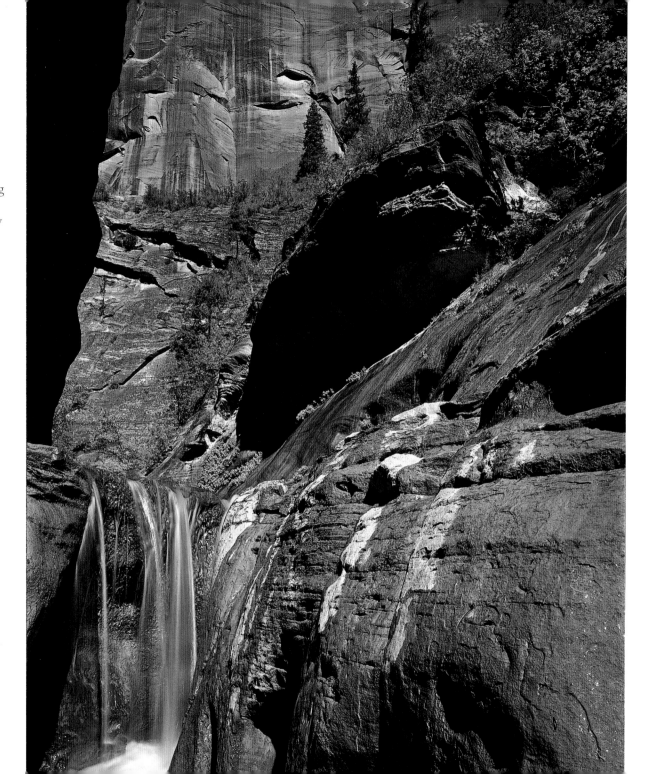

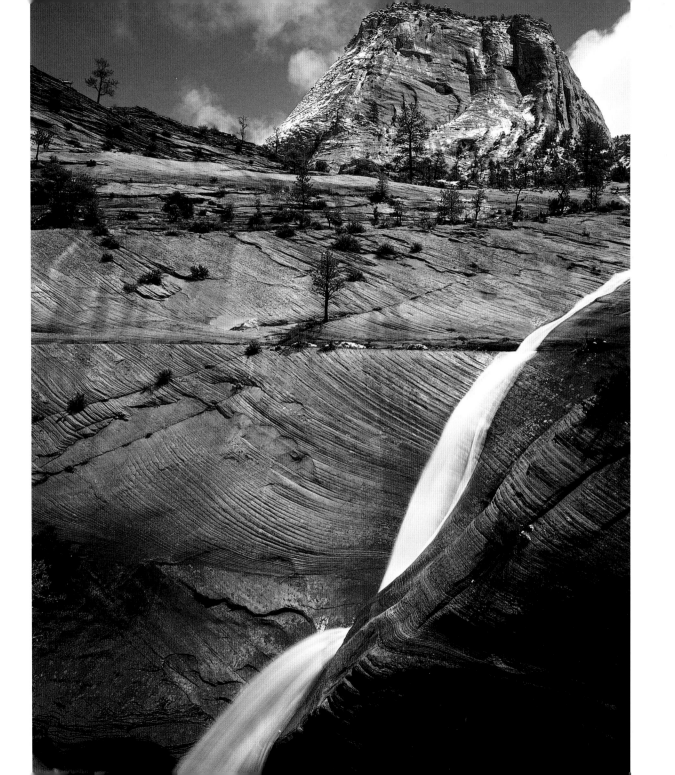

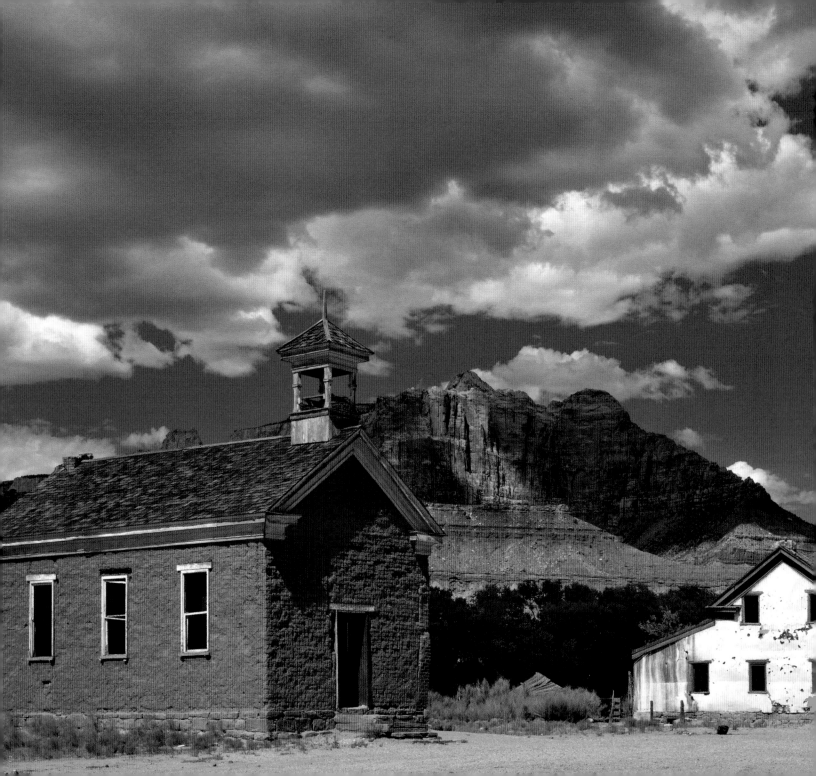

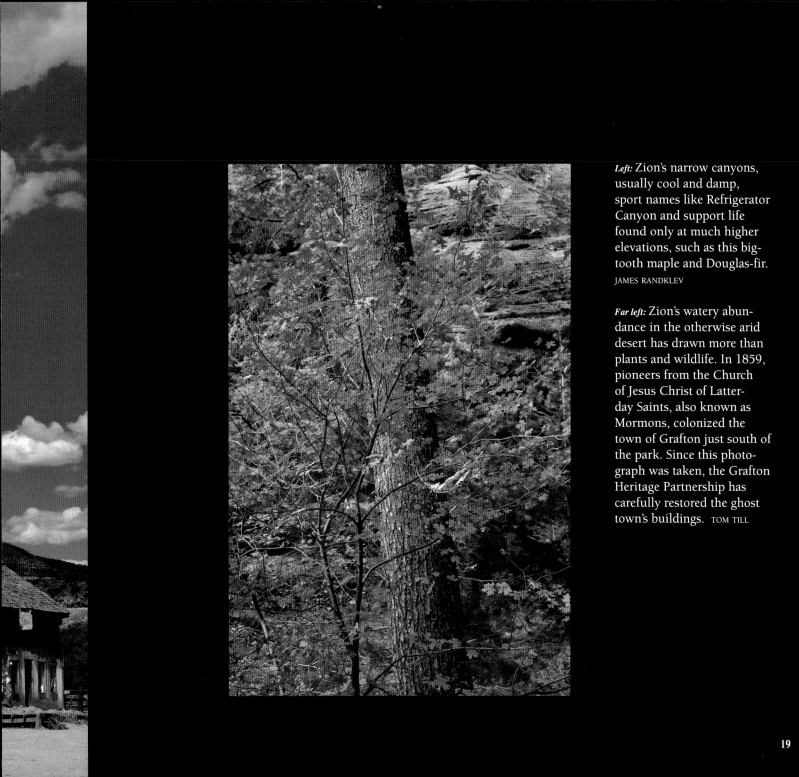

Left: Zion's narrow canyons, usually cool and damp, sport names like Refrigerator Canyon and support life found only at much higher elevations, such as this bigtooth maple and Douglas-fir. JAMES RANDKLEV

Far left: Zion's watery abundance in the otherwise arid desert has drawn more than plants and wildlife. In 1859, pioneers from the Church of Jesus Christ of Latter-day Saints, also known as Mormons, colonized the town of Grafton just south of the park. Since this photograph was taken, the Grafton Heritage Partnership has carefully restored the ghost town's buildings. TOM TILL

Right: Also called redrock or slickrock, Navajo Sandstone quickly sheds water and loose sand grains into dry washes, creating excellent beds for thirsty trees like the Fremont cottonwood. JAMES RANDKLEV

Far right: The Navajo Sandstone's cross-bedded dunes turned to stone under the weight of an advancing ocean more than 200 million years ago. Today, the calcified sands look as if they could swirl away again on the next strong breeze. Driving Zion's east side along Highway 9 reveals many such fantastic views.
JAMES RANDKLEV

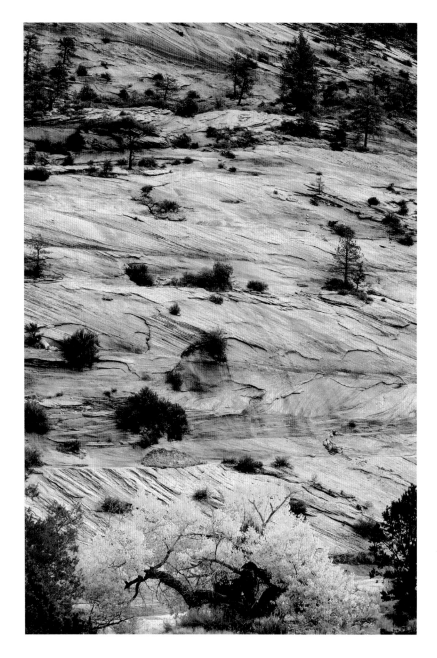

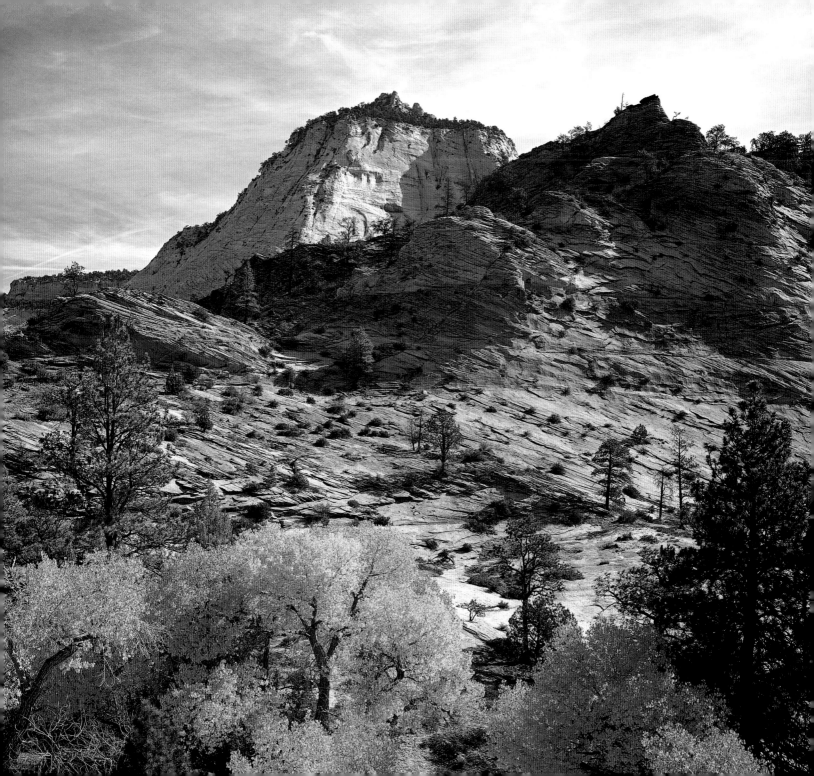

Right: Water shed by Navajo Sandstone trundles downhill, accumulating additional waters, sand, and anything loose in its path. The force of these waters running downhill at high speed carves slot canyons such as the Left Fork of North Creek. TOM TILL

Facing page: A raven's-eye view of canyon formation can be had atop Angels Landing, a two-and-one-half-mile hike from canyon bottom to knife-edge ridge. The peak was so named before the trail was constructed supposedly because only angels could land there. DAVID PETTIT

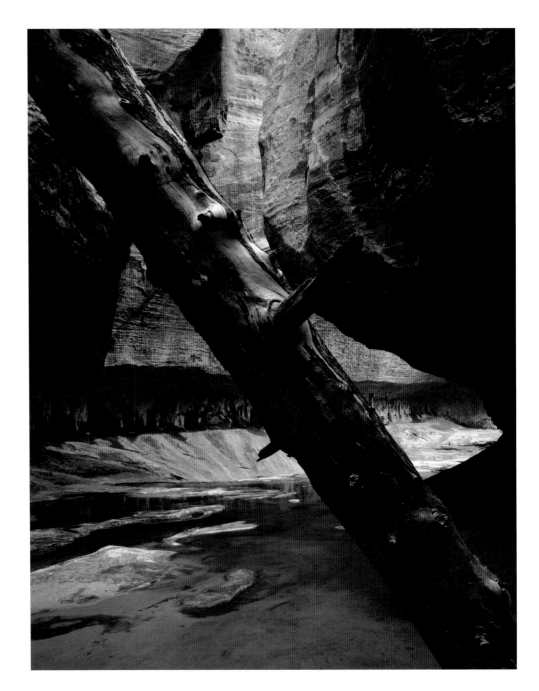

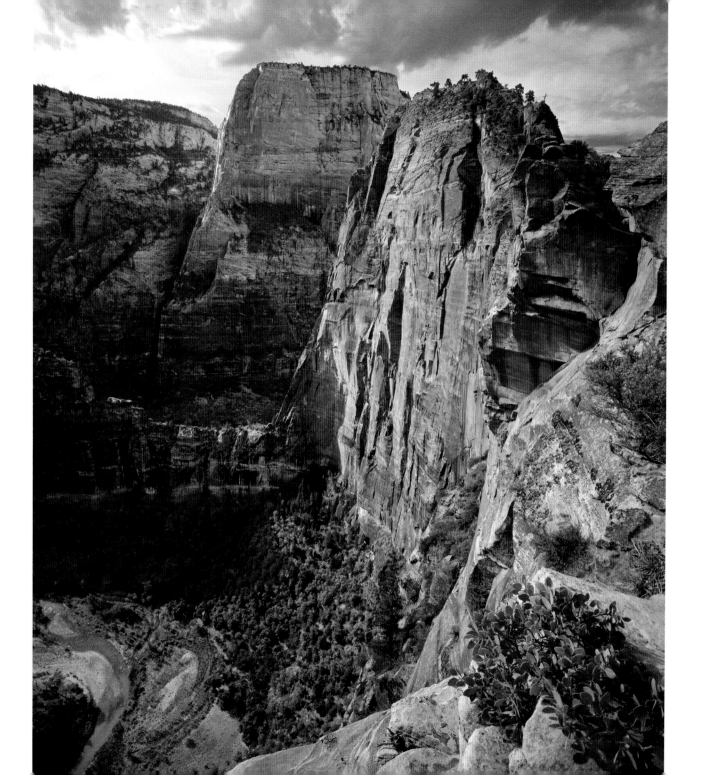

23

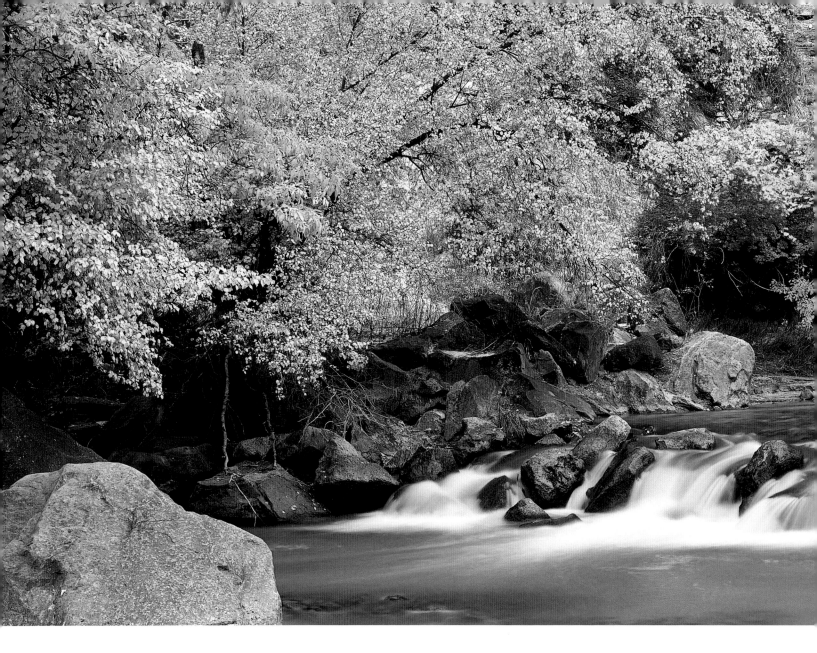

The North Fork of the Virgin River begins on the Markagunt Plateau's high top near Cedar Breaks National Monument. Its waters begin their downhill journey by seeping through lava-strewn fields into belowground conduits. This gathering underground river then bursts from a black cliff above Navajo Lake at Cascade Falls. The waters quickly gain the force necessary to move mountains, boulder by boulder. JAMES RANDKLEV

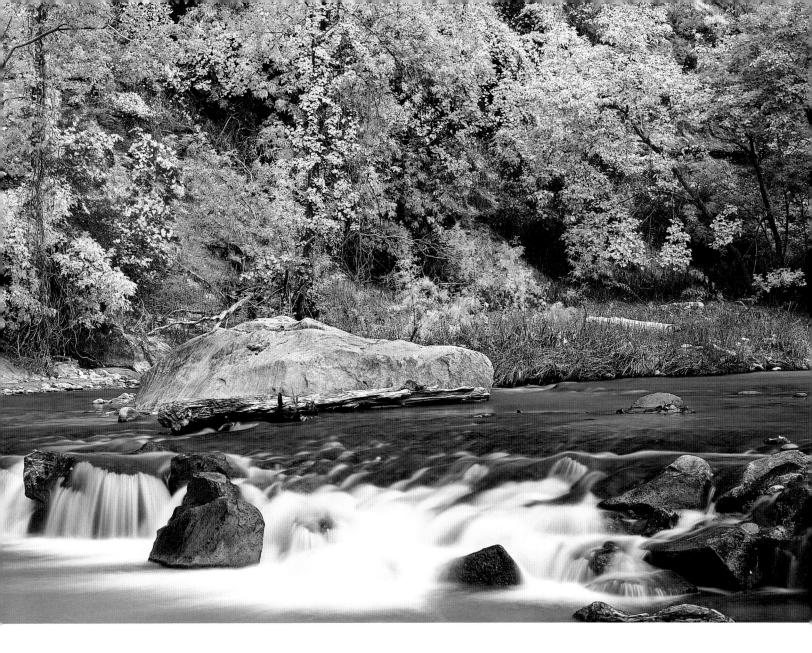

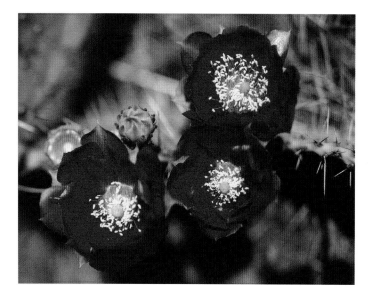

Above: Beautiful prickly pear cactus flowers produce an edible but spiny fruit that indigenous people called *tuna.* As the pioneers did, modern cooks boil the fruit to release the juice, then strain the mixture through cheesecloth to remove fine spines to make delicious, bright-red prickly pear cactus jelly. TOM TILL

Right: Sandstone pinnacles, called hoodoos, form along Zion's east side. These pinnacles are columns of eroded rock capped by an erosion-resistant boulder. JAMES RANDKLEV

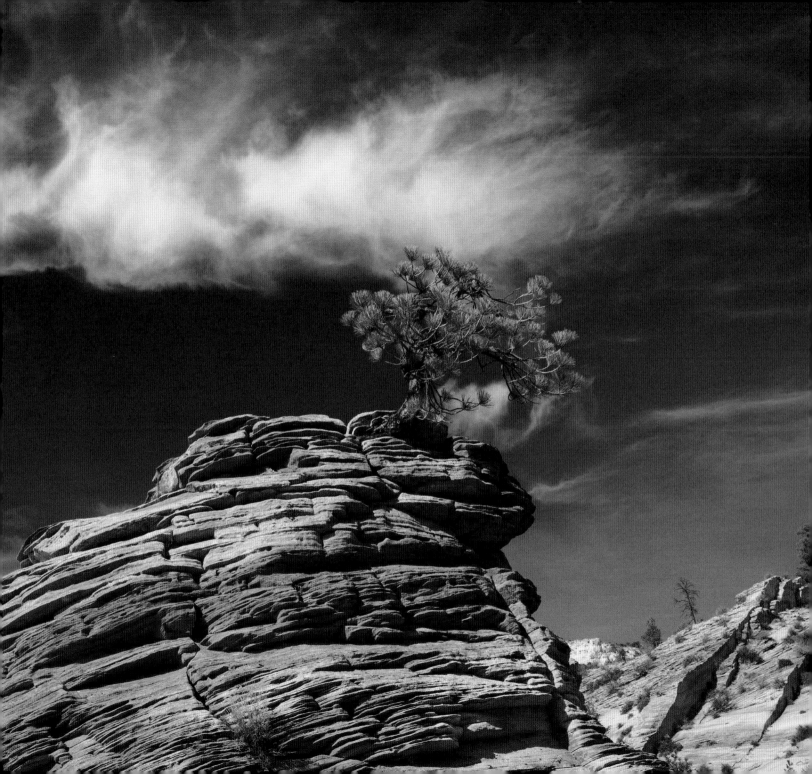

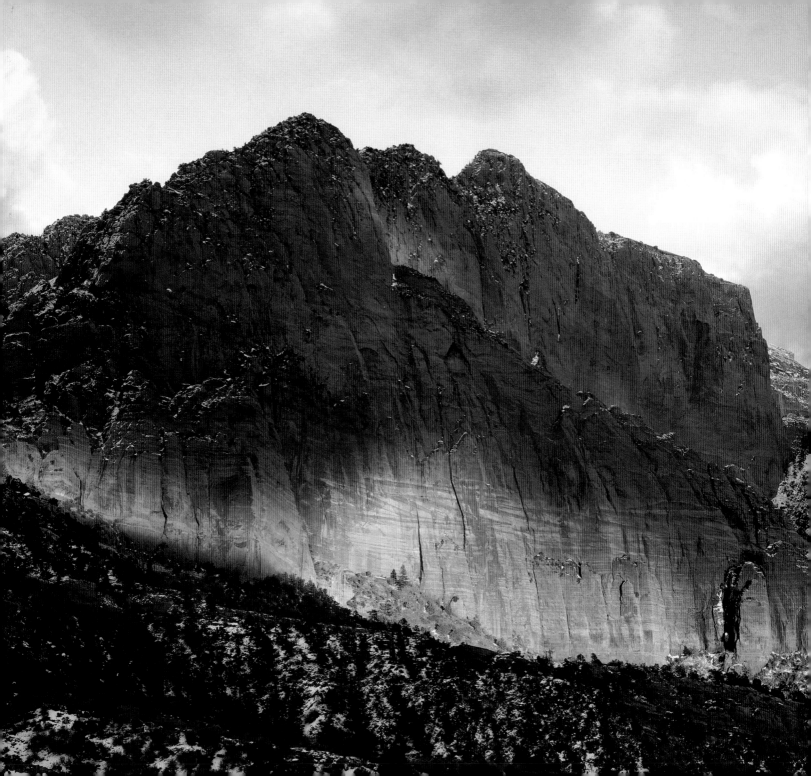

Left: Zion's Kolob Canyons are accessible from Highway 15 near New Harmony, Utah. Formed of Navajo Sandstone, the Finger Canyons are eroded not by the Virgin River but by runoff from the high-elevation Markagunt Plateau. TOM TILL

Below: A coyote blends with tawny Indian rice grass and golden snakeweed. TOM TILL

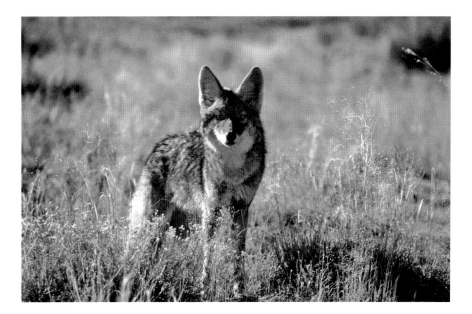

Right: The seep at Weeping Rock offers a refreshing shower on a hot summer day. The springline reveals the contact between the overlying porous Navajo Sandstone cliffs and the underlying impermeable Kayenta Shale. Water is forced out of the cliff and erodes the shale, undermining the Navajo Sandstone above and widening the canyon.

JAMES RANDKLEV

Far right: Cable Mountain looms over Zion Canyon. Pioneers constructed a sawmill atop its broad mesa, harvested ponderosa pine, and lowered sawn boards to the canyon floor on a massive cableworks. The wooden headframe can still be glimpsed by the eagle-eyed.

JAMES RANDKLEV

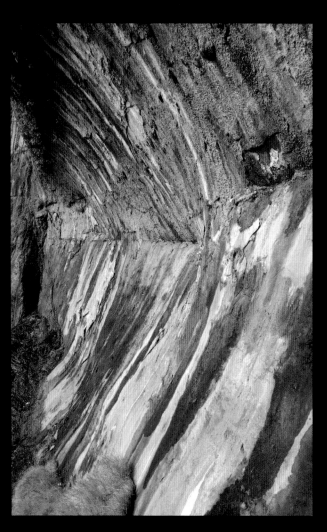

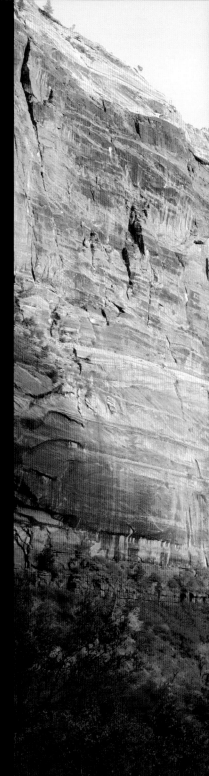

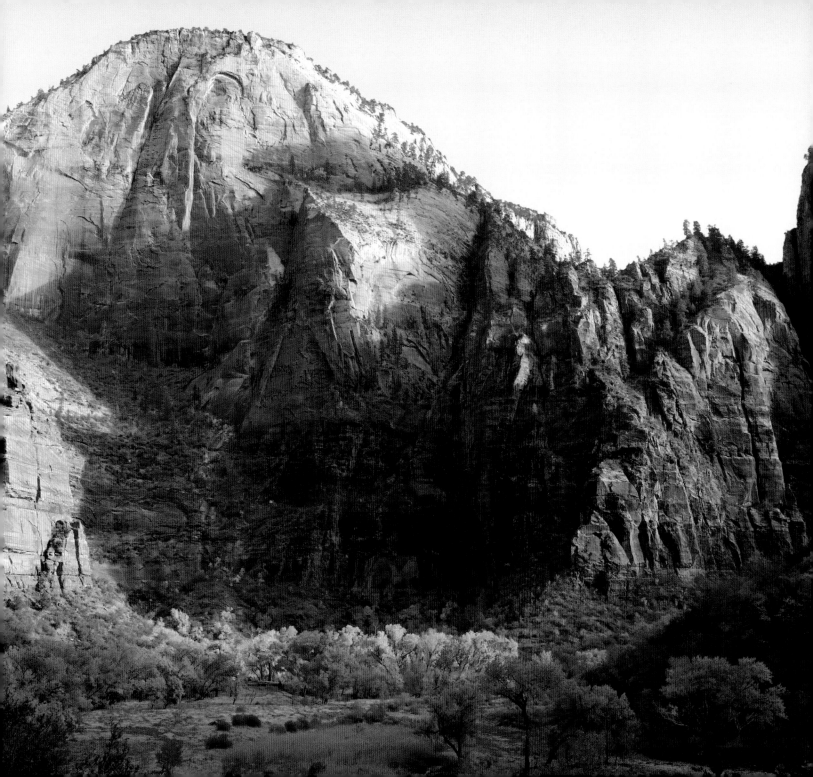

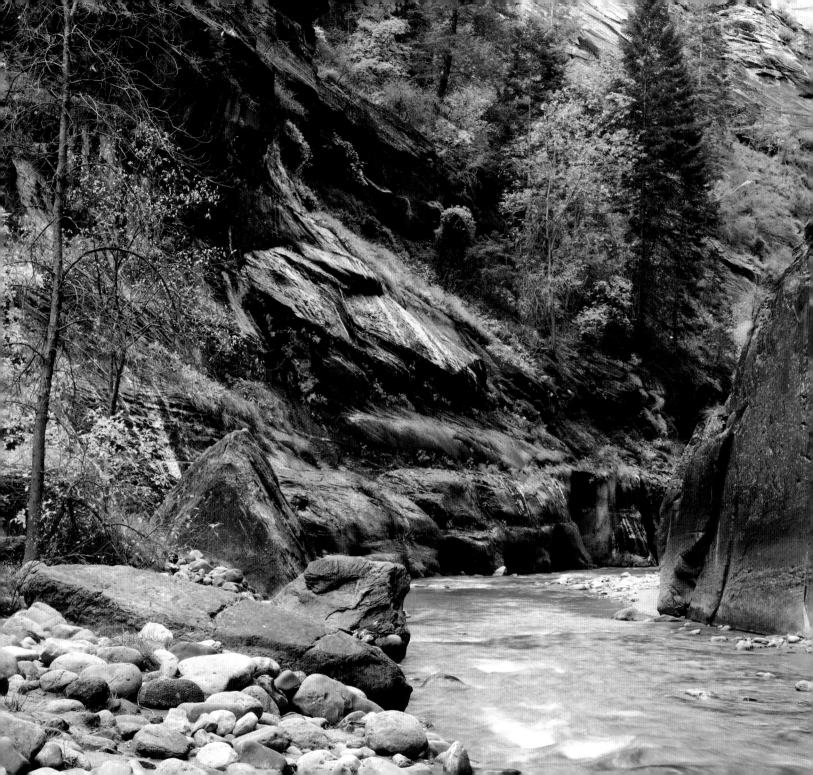

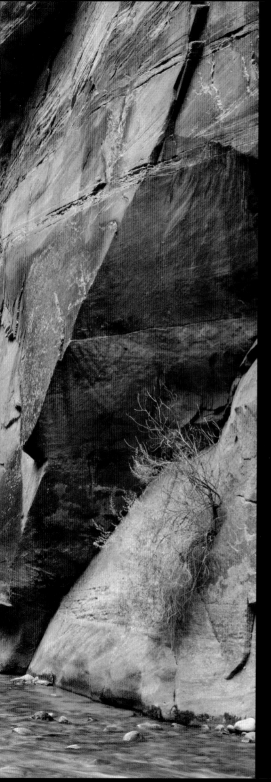

Left: The Virgin River Narrows is a stimulating and wet hike. Hikers must cross sandbar to sandbar, walking over slippery submerged boulders that are often knee- or chest-deep in water. The narrowest canyon section lies one-and-one-half miles upriver from the end of the Riverside Walk. JAMES RANDKLEV

Below: In the narrowest part of the Narrows, hikers walk exclusively in water. If you plan on going, wear solid footwear, take a walking stick for balance, and pack a warm sweater in spring and fall. Be sure to check for flashflood danger at the visitor center before beginning your hike. JAMES RANDKLEV

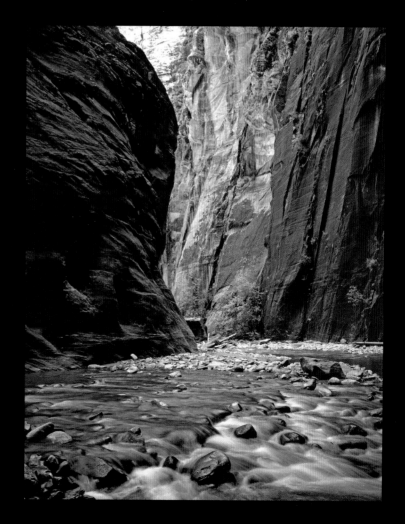

Right: Zion Canyon's flat floor formed beneath an ancient lake, dammed by a massive rockfall 8,000 years ago. In the millennia since the lake drained 4,000 years ago, the flat, river-watered land drew Native American and Euro-American farmers alike. JAMES RANDKLEV

Far right: The Riverside Walk winds along the Virgin River and leads from the Temple of Sinawava to the Zion Narrows. A pleasant one-mile walk, the trail is paved and suitable for strollers and wheelchairs with assistance. JAMES RANDKLEV

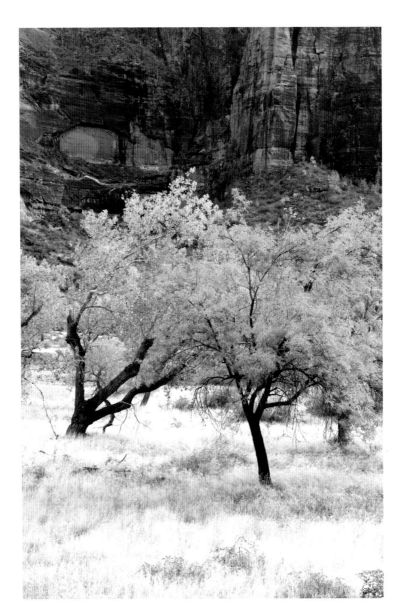

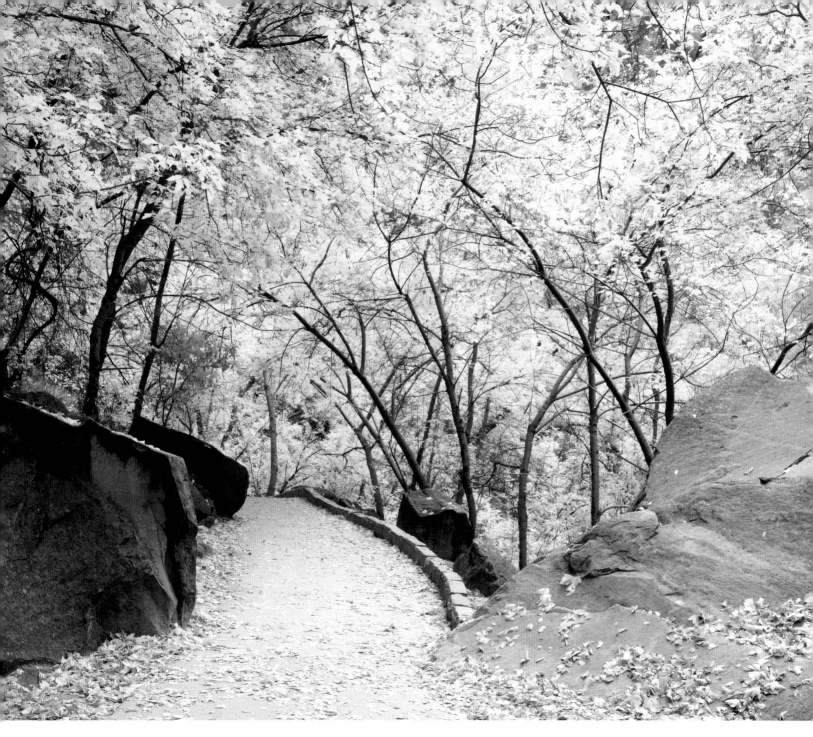

Right: Although the floor of Zion Canyon doesn't hold snow for long, the upper elevations accumulate heavy loads. Many high-country trails are closed during winter due to deep snow. In spring, melting recharges rivers and springs and turns dry washes into rushing creeks. TOM TILL

Below: Snow outlines Navajo Sandstone cross-beds along Zion's east side. TOM TILL

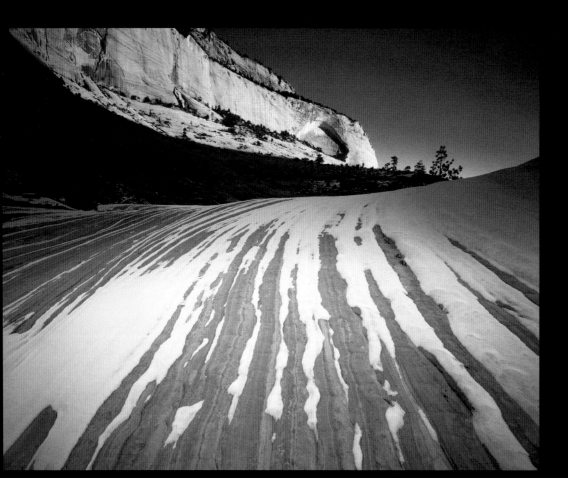

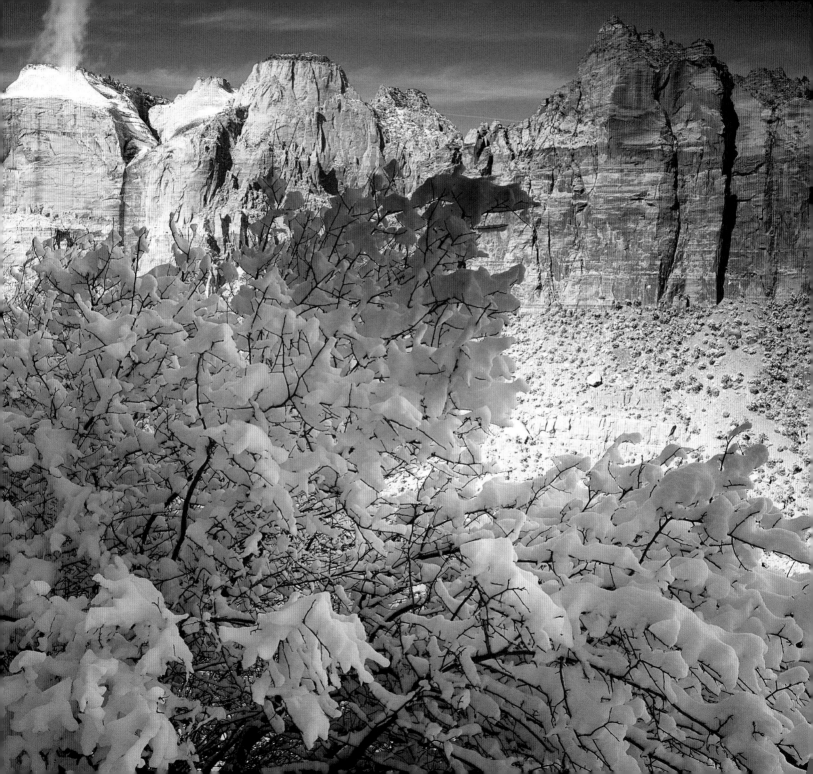

Right: Checkerboard Mesa, on Zion's east side, displays an interesting erosional pattern. Rain and snowmelt running down the mesa's face erode vertical lines, while wind and water wear horizontal grooves. Cycles of freezing and thawing pop the rock along bedding planes. The resulting blocks, called biscuits, give the mesa its namesake design.
JAMES RANDKLEV

Far right: The East Temple, as seen from Bridge Mountain. In a phenomenon poorly understood, Zion's Navajo Sandstone formations are often white at higher elevations and red in the lower areas.
TOM TILL

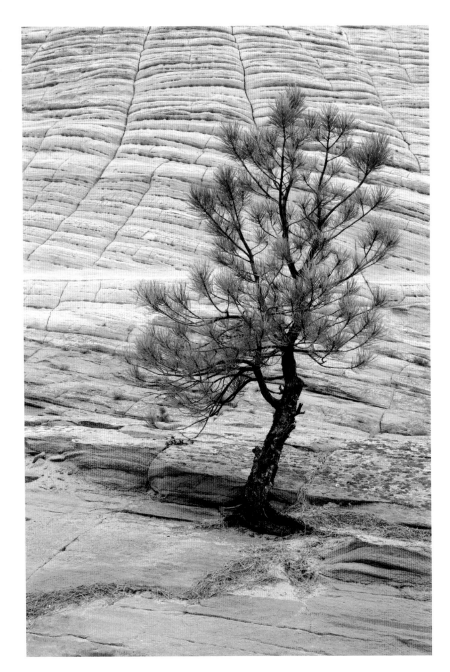

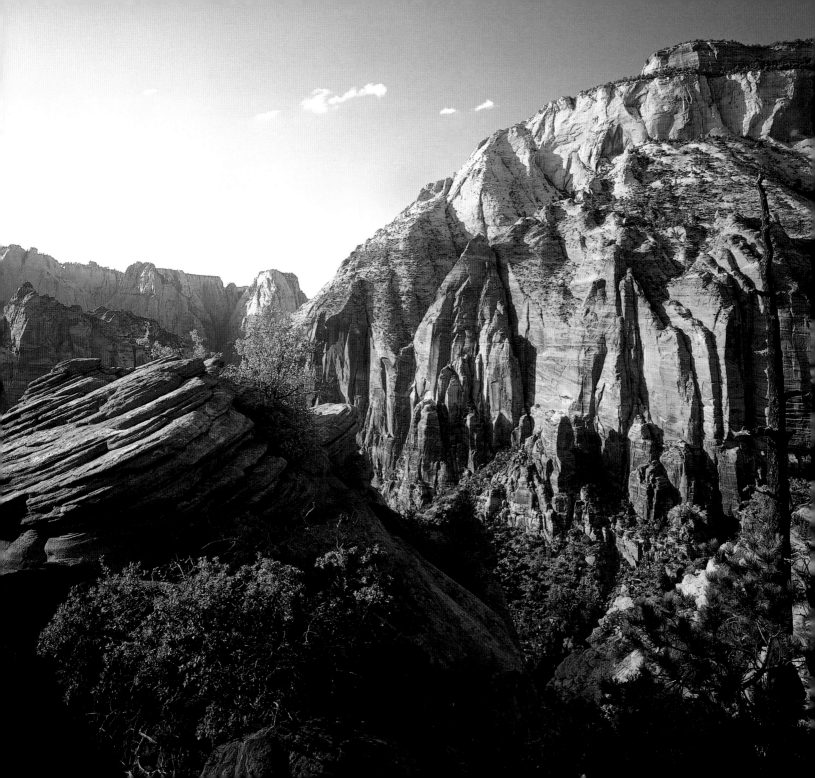

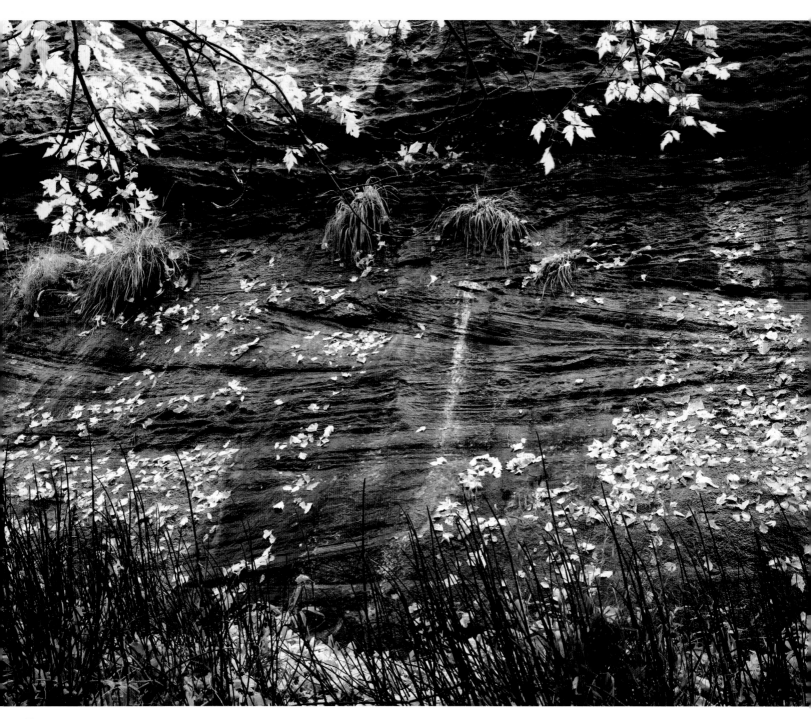

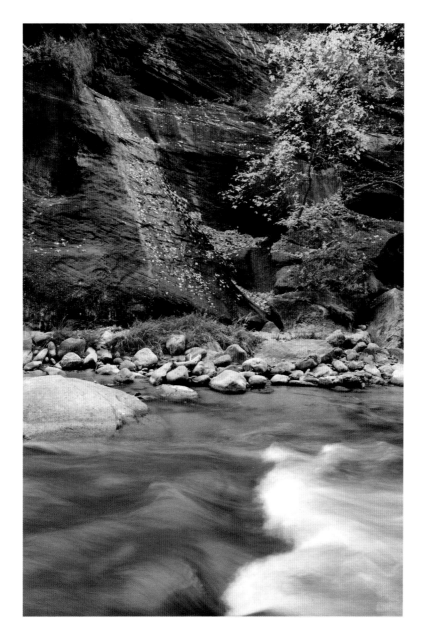

Left: This golden box elder would quickly perish without the nearby stream of water to wet its roots. Cactus and other desert-evolved plants would quickly perish if planted near water. All plants are uniquely adapted to grow exactly where they do.
JAMES RANDKLEV

Far left: Golden box elder leaves highlight the Navajo Sandstone's dark desert varnish. Wherever water flows—whether a seep, spring, stream, or river—desert vegetation is replaced with water-loving plants.
JAMES RANDKLEV

Right: The Sentinel Slide's red slope crowds the Virgin River. Eight thousand years ago, an immense rock slab fell 2,000 feet from the vertical peak above, pulverizing itself on the way down and damming the Virgin River for 4,000 years. During that time, Zion Lodge would have been 300 feet beneath the surface of a vast lake.
JAMES RANDKLEV

Facing page: Black desert varnish covers white Navajo Sandstone in the Narrows. Wind paints a combination of minerals, clays, bacteria, and other organic materials across the canyon walls, where it adheres, lending cliffs an array of color.
JAMES RANDKLEV

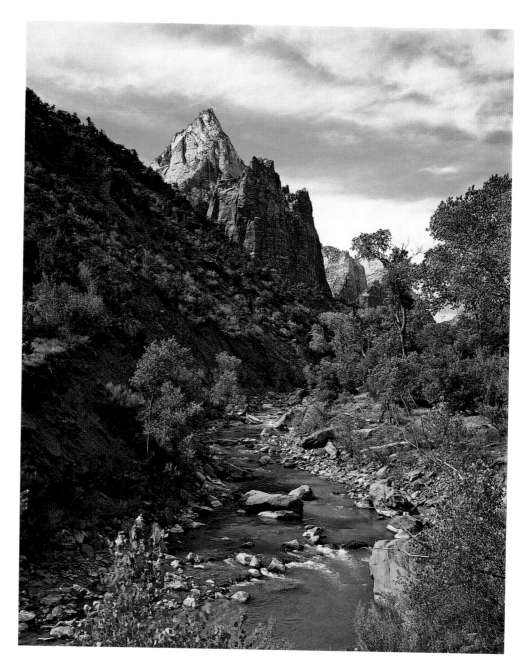

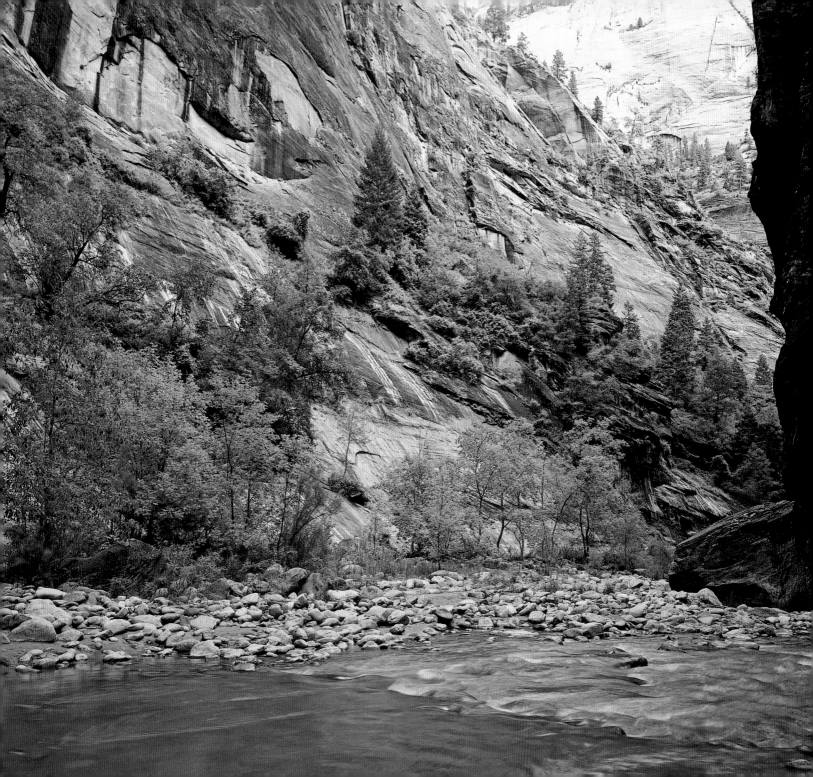

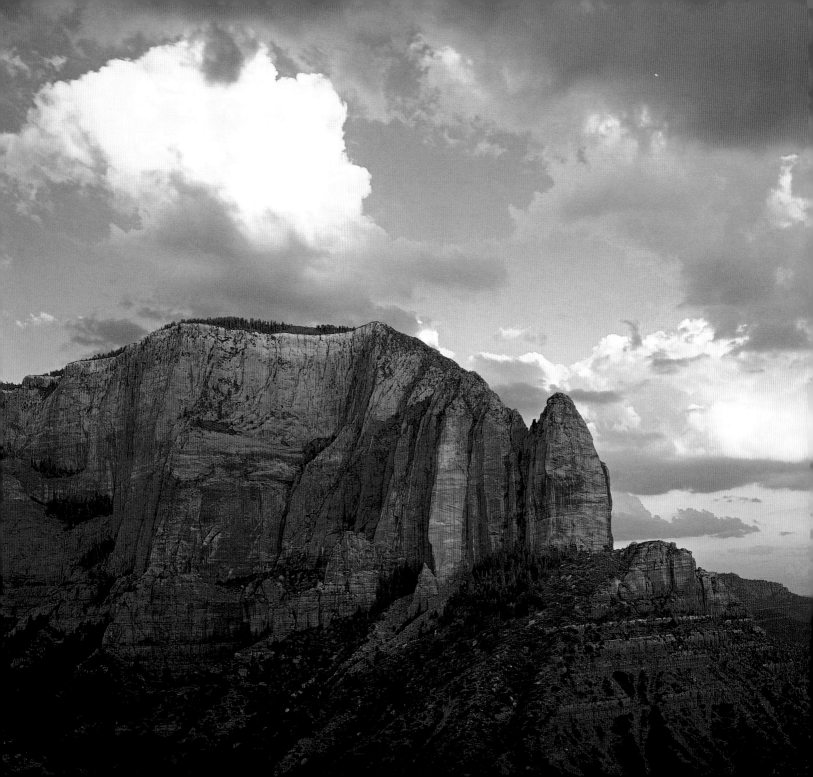

Left: Timber Top Mountain (with Shuntavi Butte on the right) tops 7,600 feet. Zion National Park ranges in elevation from 4,000 feet near the South Entrance to 8,726 feet at its highest point on Horse Ranch Mountain. Such a wide elevation range supports diverse ecosystems. Elk and marmots live on high mesas, while snakes and lizards thrive in the lower desert. TOM TILL

Below, left: Collared lizards stand up on their hind legs and run down their prey, which includes smaller lizards. The colorful reptiles grow to about ten inches in length. TOM TILL

Below, right: A Great Basin gopher snake resembles a rattlesnake. It will flatten its head, hiss, and vibrate its tail to fool predators. TOM TILL

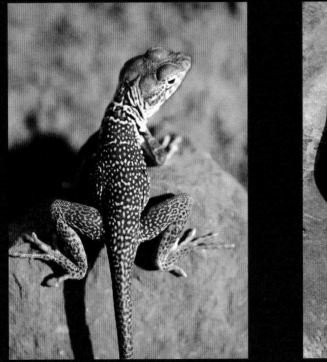
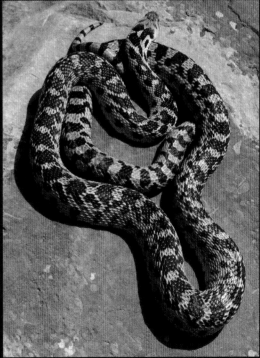

Right: Springs, such as the Emerald Pools, which sit at the base of the trees, form wherever the upper, porous Navajo Sandstone cliffs contact the lower impermeable Kayenta Shale. The contact squeezes moisture from the stone, providing much-needed water for desert dwellers such as fall-reddened bigtooth maple, golden box elder, and towering ponderosa pine. JAMES RANDKLEV

Far right: The view of Zion Lodge and the main canyon road from Middle Emerald Pool Trail. Three pioneers built homesteads and farms in this area in the 1860s. In a process that continues today, all were washed out by flashfloods.
JAMES RANDKLEV

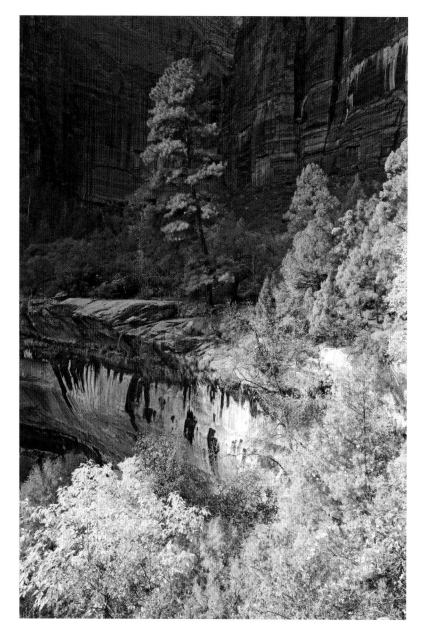

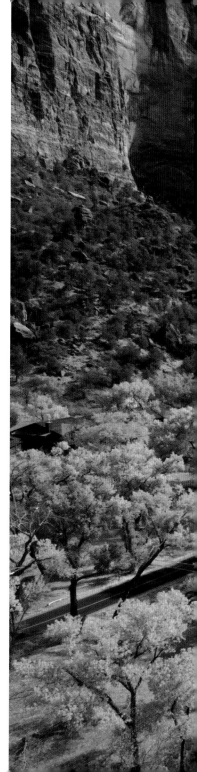

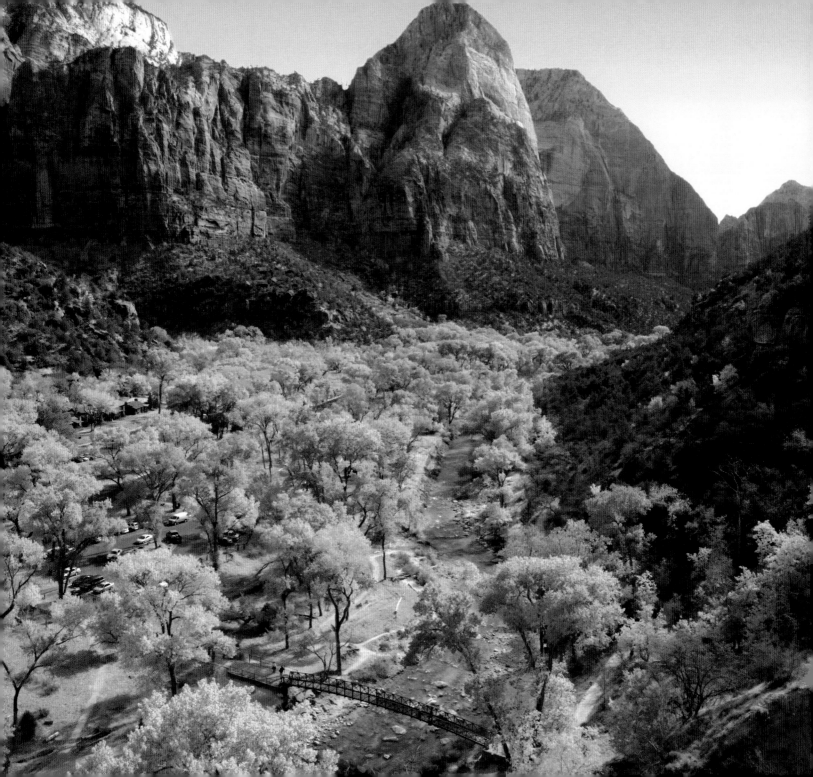

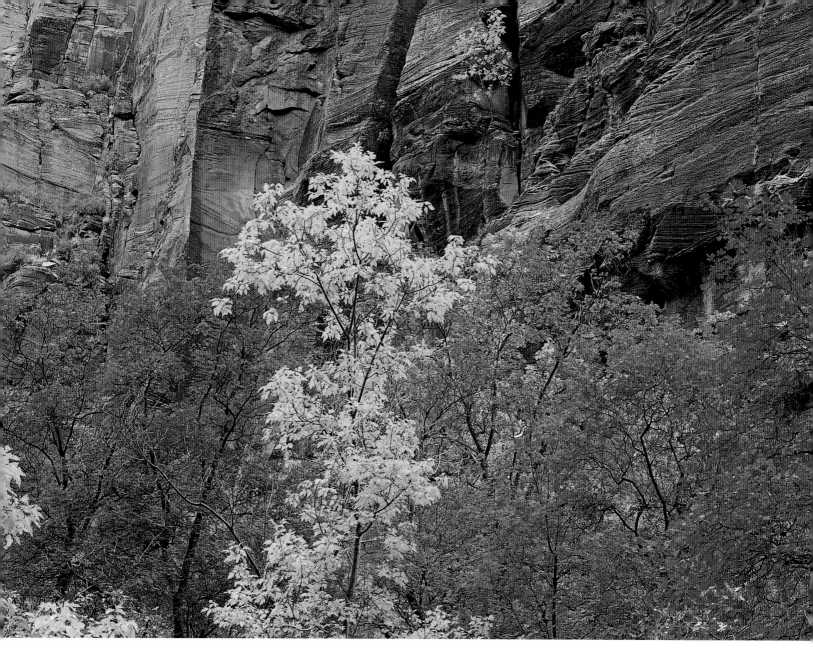

Crimson bigtooth maples, yellow box elder, and golden wild grape vines turn Zion Canyon into a fall delight. JAMES RANDKLEV

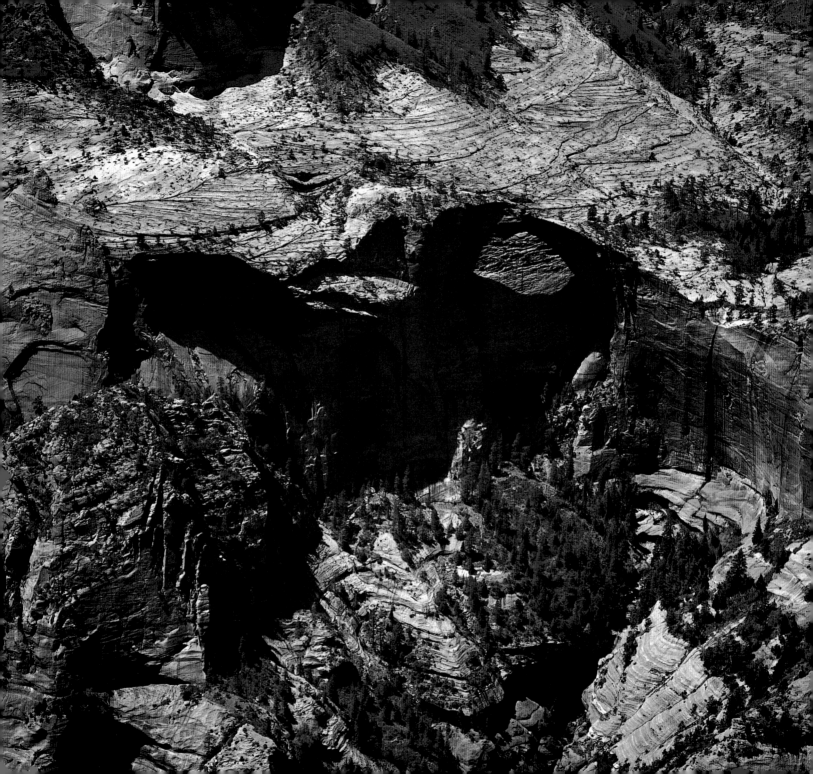

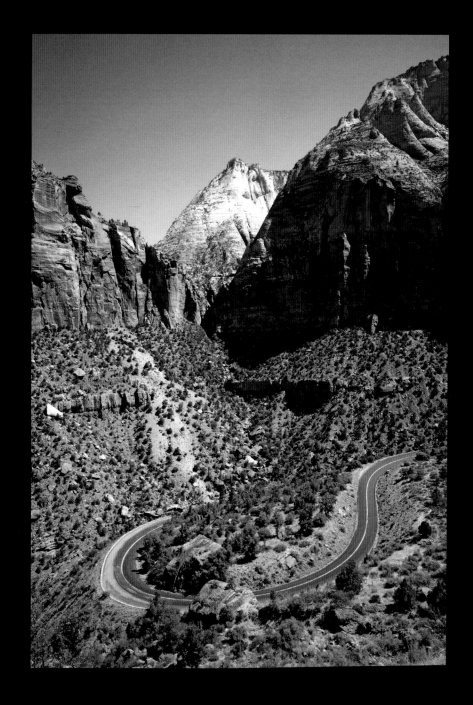

51

Right: Mule deer are common in Zion Canyon, and visitors frequently spot them from the shuttle bus headed up-canyon. Although mule deer usually prefer higher elevations, Zion Canyon's abundant water draws them in. JAMES RANDKLEV

Far right: Lush vegetation along Weeping Rock Trail is supported by moisture dripping from Weeping Rock seep. A rivulet forms and trickles below the trail. Only a quarter-mile long, the trail is a pleasant place for a stroll on a fall day.

JAMES RANDKLEV

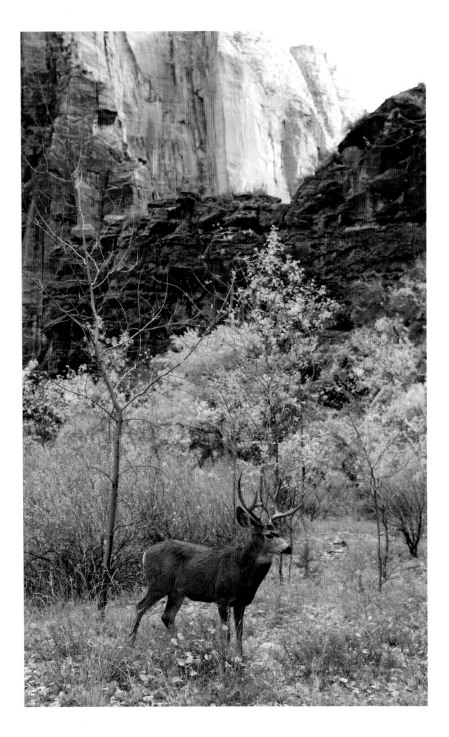

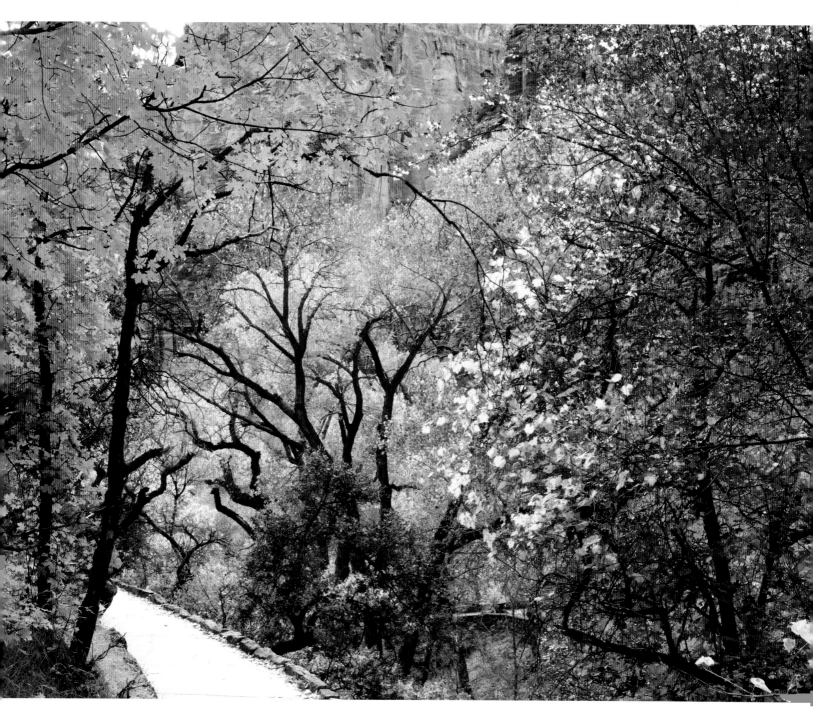

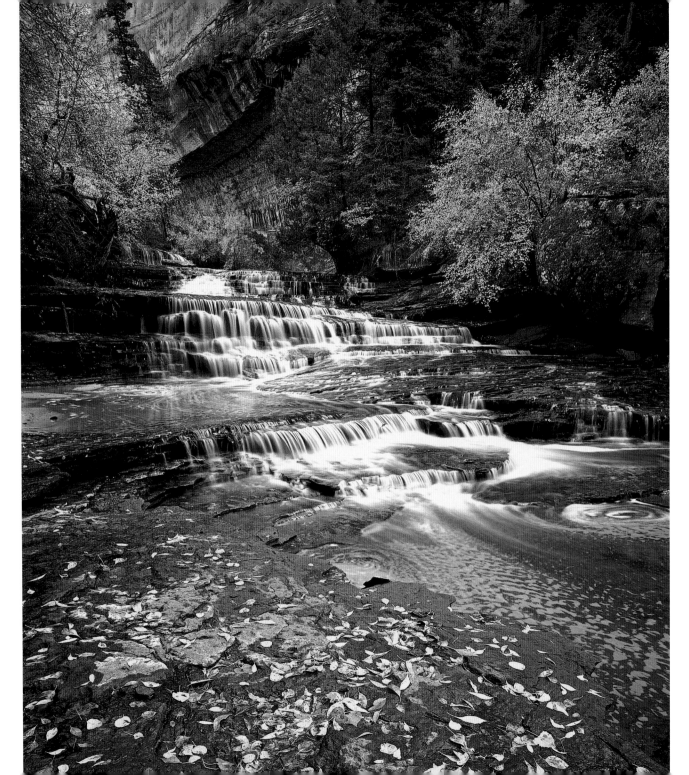

Water cascades over Kayenta Shale in the Left Fork of North Creek. The Kayenta Shale flakes into fragile ledges, forming small water-falls, seeps, and springs throughout the canyons.

TOM TILL

54

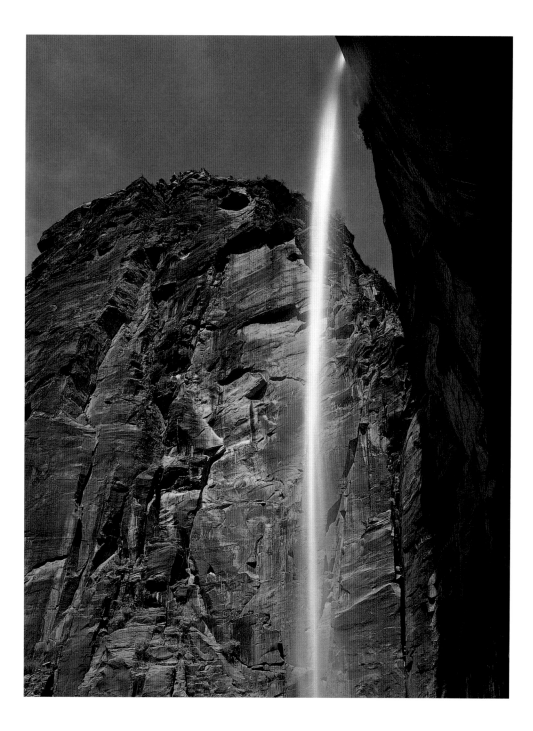

During spring runoff and after summer rains, waterfalls pour from hidden canyons, such as this falls over Weeping Rock. Bare slickrock channels the runoff into smaller, usually dry canyons far above the main canyon floor. Waters, in their rush to join the Virgin River, leap from hanging canyons. TOM TILL

Right: Mount Majestic, The Spearhead, and Cathedral Mountain tower over the Virgin River. It's hard to believe that this small river is responsible for carving Zion's massive formations. The ingredients needed to form Zion Canyon were high elevation, flowing water, a very large sandstone block, and time, lots and lots of time. JAMES RANDKLEV

Below: The Pulpit in the Temple of Sinawava. Zion's names reveal time's cultural mix. Sinawava is a deity sacred to the Southern Paiute people who lived, and continue to live, near Zion Canyon. Many Mormon and other religious names were bestowed in the late nineteenth and early twentieth centuries. JAMES RANDKLEV

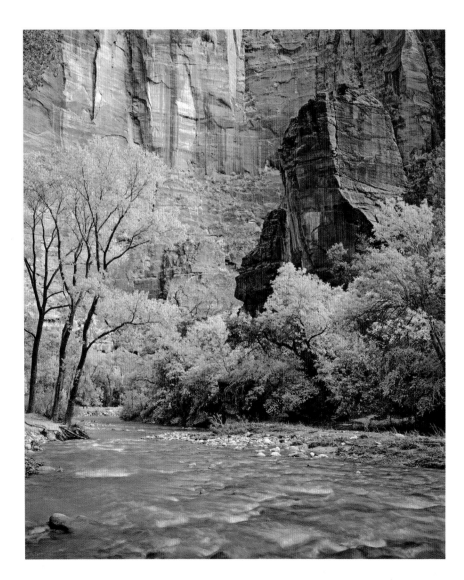

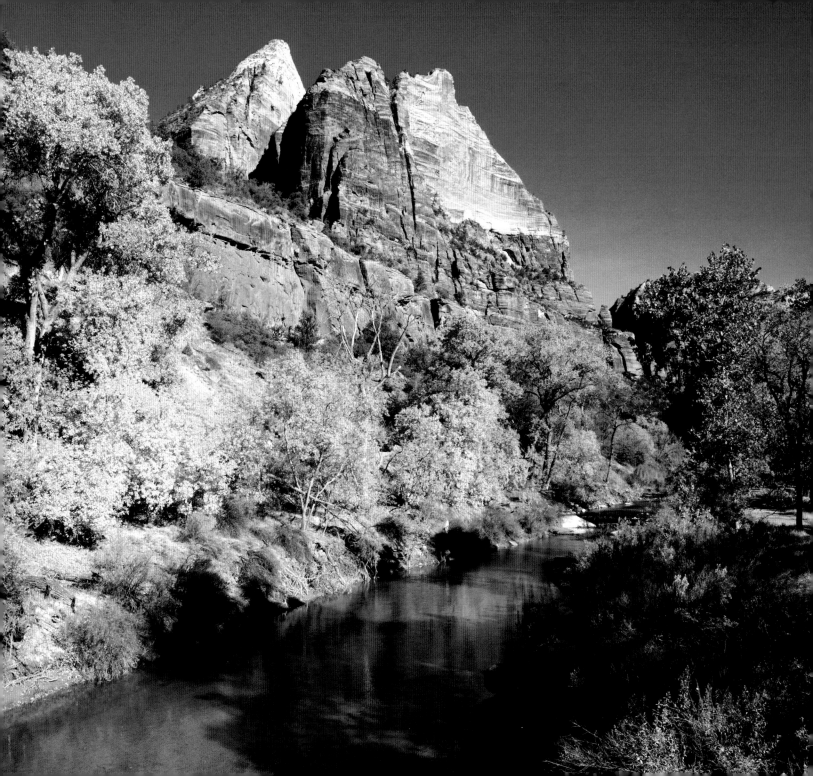

Right: Navajo Sandstone's redrock patina is like rouge on an alabaster cheek. Where rockfalls calve, underlying rock remains sandy white. The Navajo's blush comes from iron's oxidation: rust.

JAMES RANDKLEV

Far right: Designed by Gilbert Stanley Underwood in the 1920s, Zion Lodge was destroyed by fire in 1966. The lodge was rebuilt, but Underwood's classic "parkhitecture" was abandoned for a jarring 1960s motor-lodge look. In 1990 the exterior was restored to its original stately appearance.

JAMES RANDKLEV

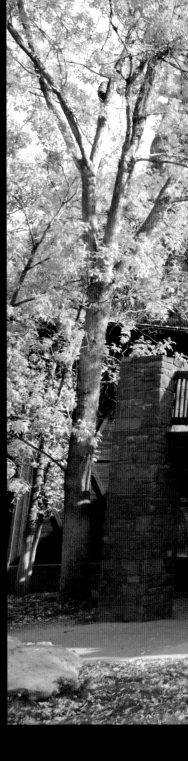

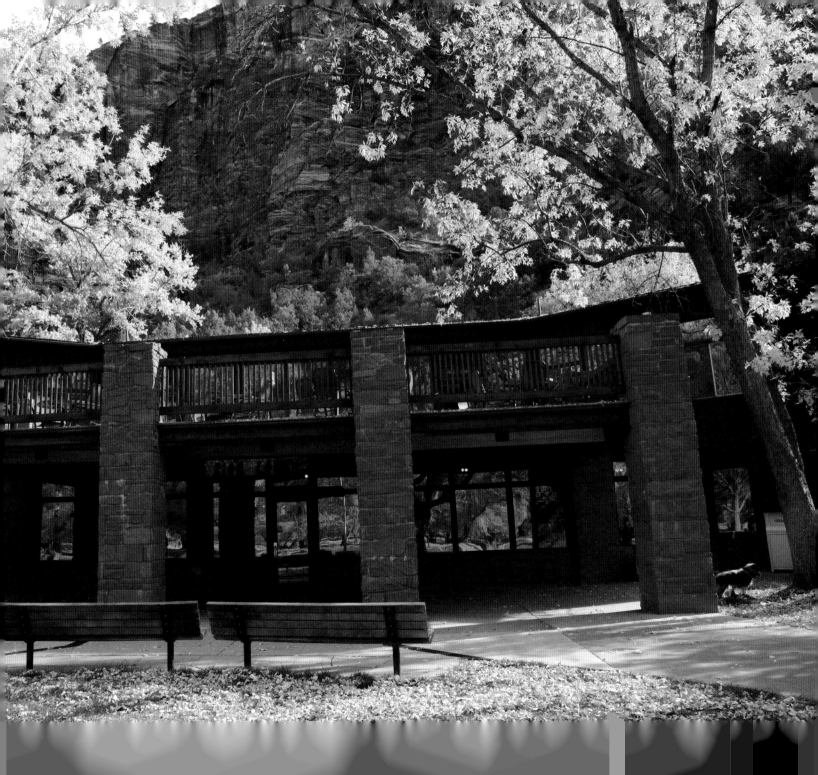

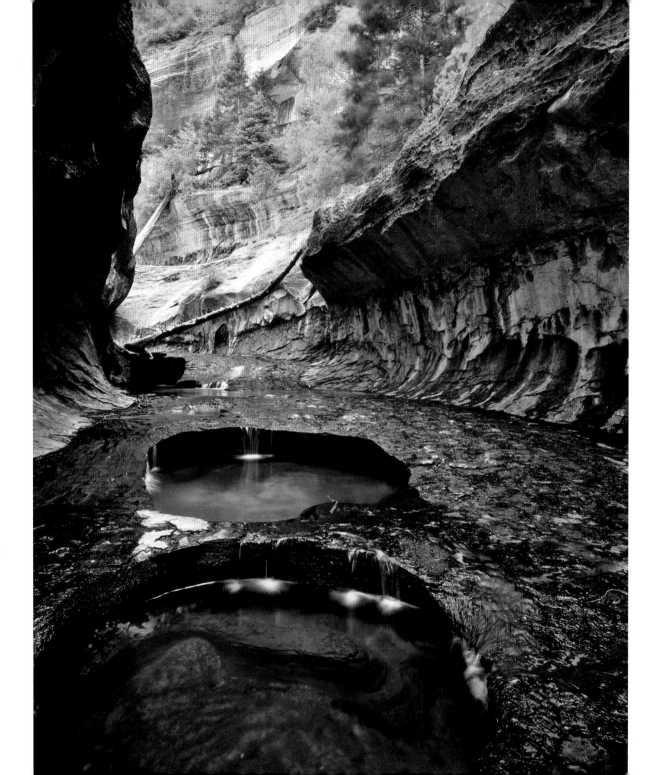

Right: The Subway, along the Left Fork of North Creek, is a spectacular canyoneering spot. However, narrows can be deadly for the unaware. Flashfloods form without warning when rains fall up-canyon and roar like freight trains through slot canyons. Slick, over-hanging, and sheer walls make escape impossible. TOM TILL

Facing page: Moss, scarlet monkeyflower, and maidenhair fern surround Big Spring in the Virgin River Narrows. Water falling on canyon peaks as rain or snow perco-lates through 2,000 to 3,000 feet of sandstone before emerging as a spring. Such a journey takes 1,000 to 4,000 years. TOM TILL

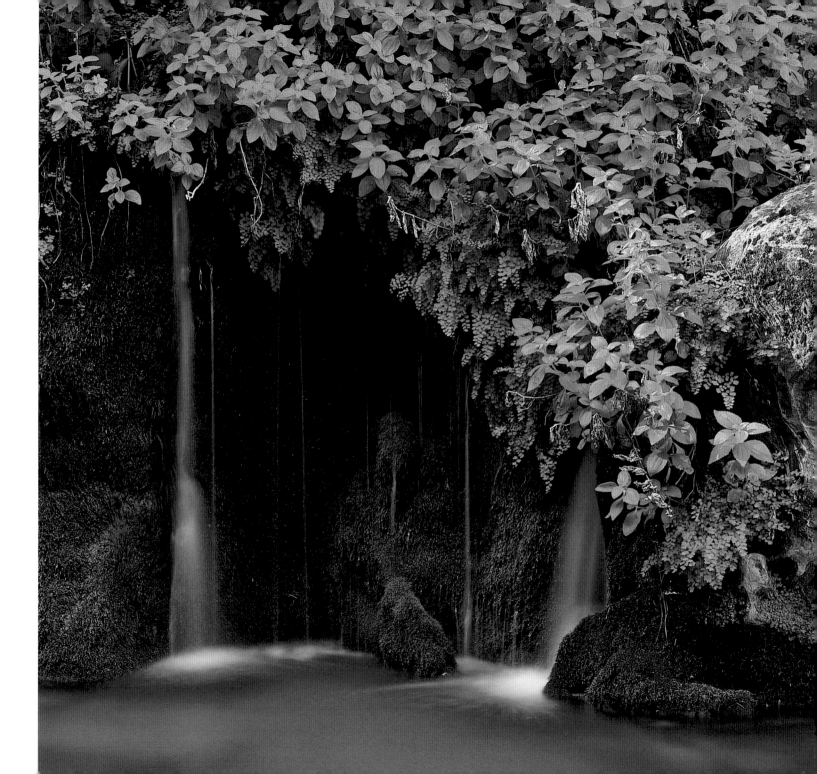

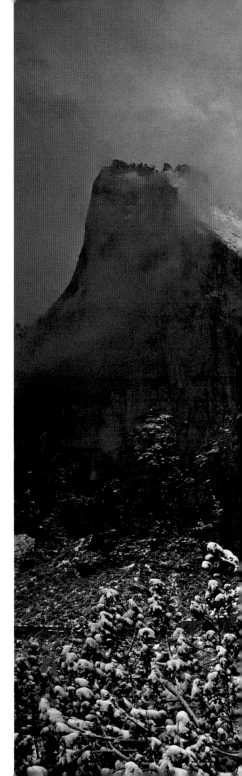

Right: In 1916 Frederick Vining Fisher, a Methodist missionary and national park advocate, named the Great White Throne and, with his local guide Claud Hirschi, the Three Patriarchs (shown here). The Mormon faith echoes in names like Mount Moroni and Kolob Canyons. Zion, a word interpreted as "refuge," is borrowed from Hebrew. <small>TOM TILL</small>

Below: Bigtooth maple leaves lie frozen in winter's first chill. <small>JAMES RANDKLEV</small>

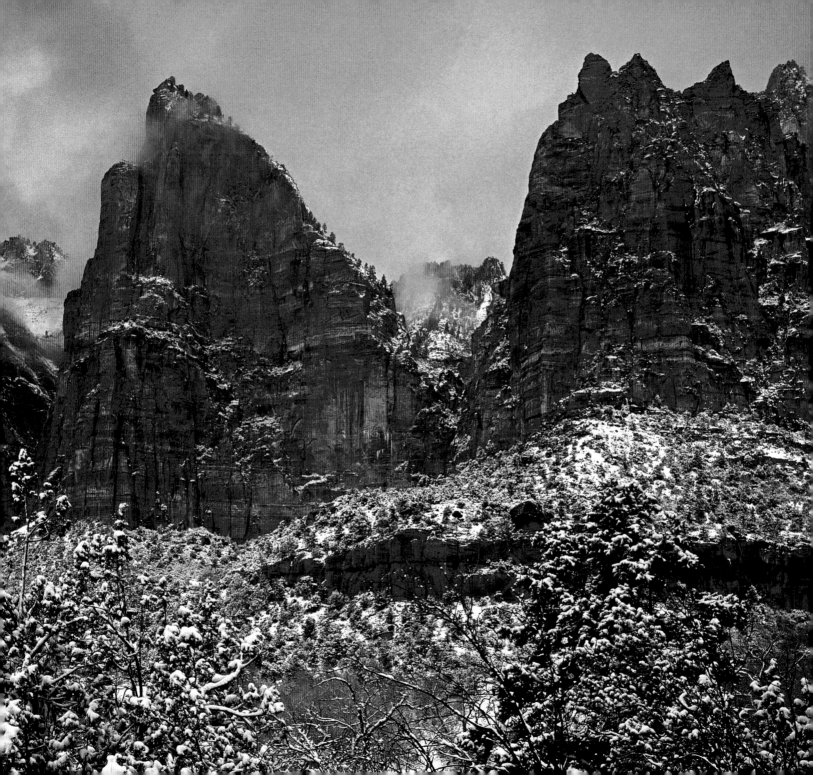

Right: The middle peak of the Three Patriarchs, what locals call Isaac, was carved by three creeks —one flowing on each side—headed for the Virgin River, pictured here. TOM TILL

Below, left and right: Double Arch Alcove, in Taylor Creek, Kolob Finger Canyons, is formed by an unusual array of two blind arches above a spring-formed alcove. Blind arches form when a massive rock overhang finally breaks under its own weight, leaving an arch-shaped recess in the cliff face. Alcoves form along springlines as water's incessant drip slowly erodes rock. Colorful patinas emerge as water precipitates minerals, soils, and algae—geological hieroglyphics. TOM TILL

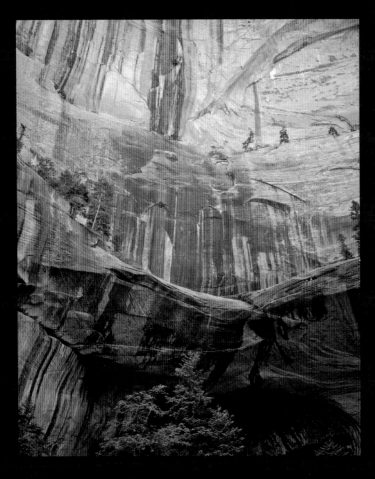
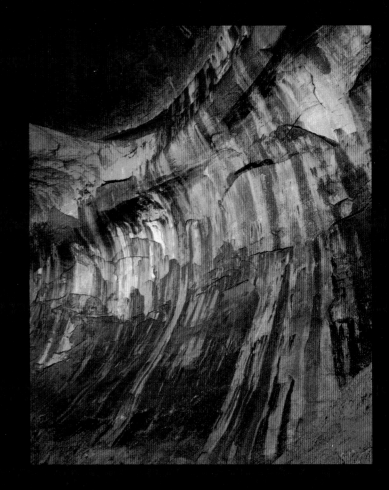

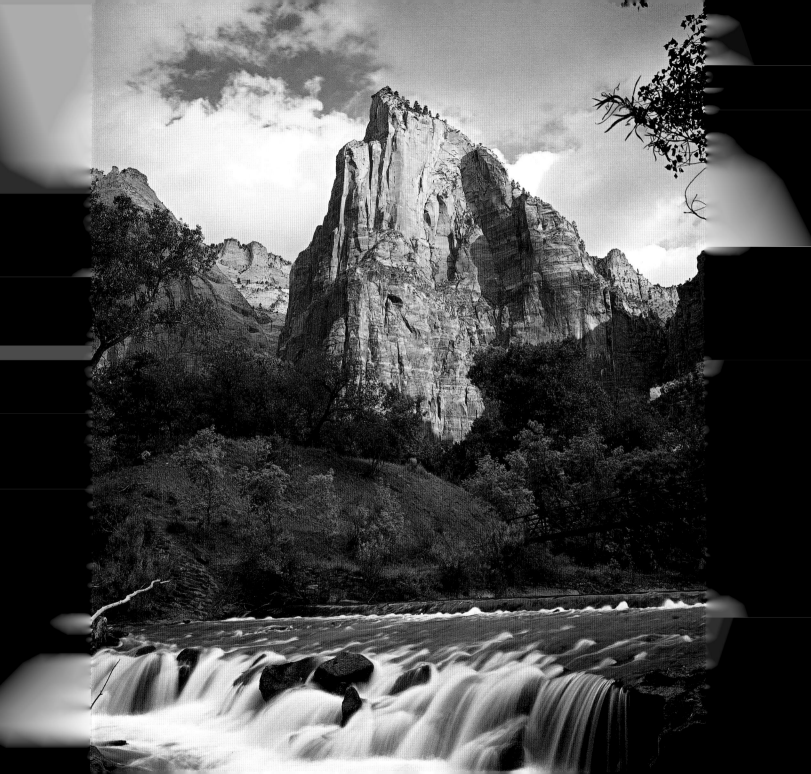

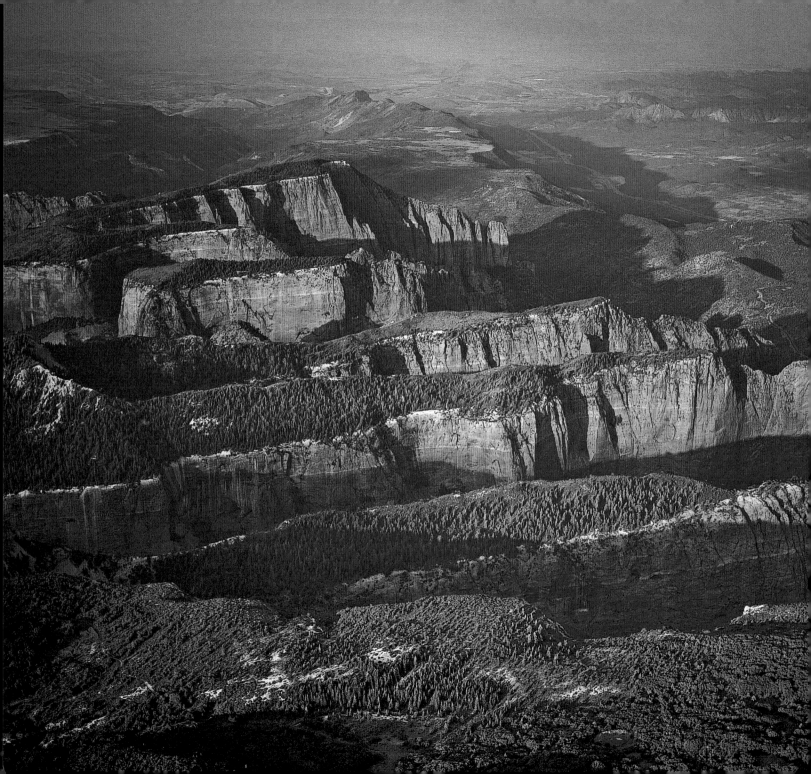

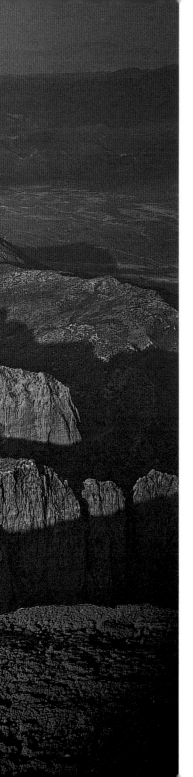

Left: An aerial view of the Kolob Canyons, lined up like a hand's digits, reveals why they are called the Finger Canyons. Zion's high elevations support tall ponderosa pines, which account for the name of nearby Timber Top Mountain. The Kolob represents the western edge of the uplifted physiographic province known as the Colorado Plateau. To the west the lower Basin and Range District stretches all the way to California's Sierra Nevada. TOM TILL

Below: A Douglas-fir's roots cling tenaciously to its cliffside perch. JAMES RANDKLEV

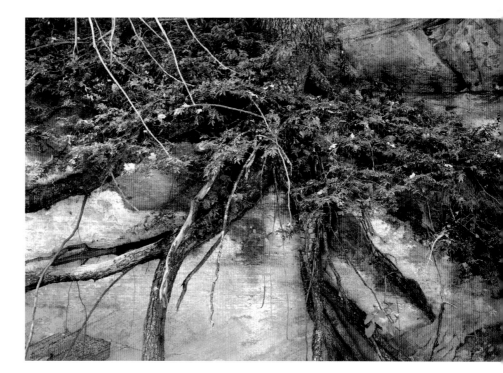

Right: Young box elder trees spring up in a damp Zion side canyon. JAMES RANDKLEV

Far right: Dust to dust. Narrow canyons on Zion's east side collect rusty sand grains as Navajo Sandstone erodes into its constituent parts. Once a desert of sand dunes, so it becomes again. TOM TILL

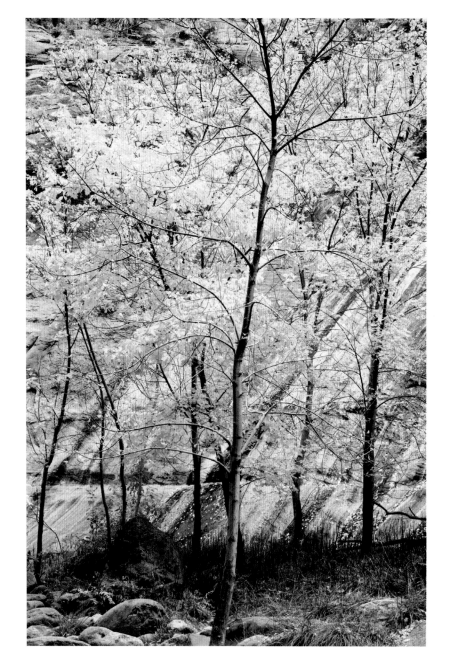

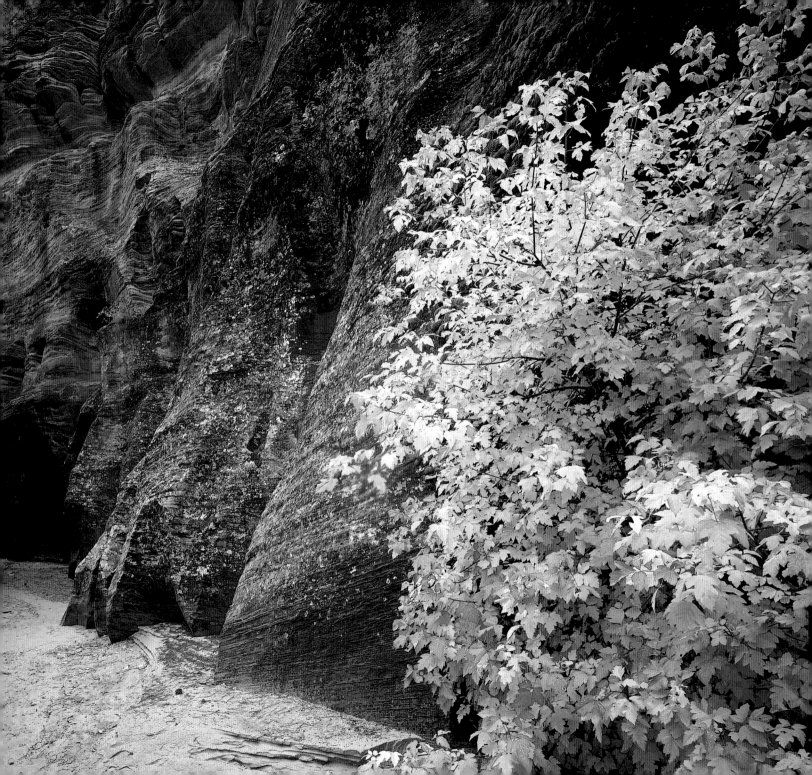

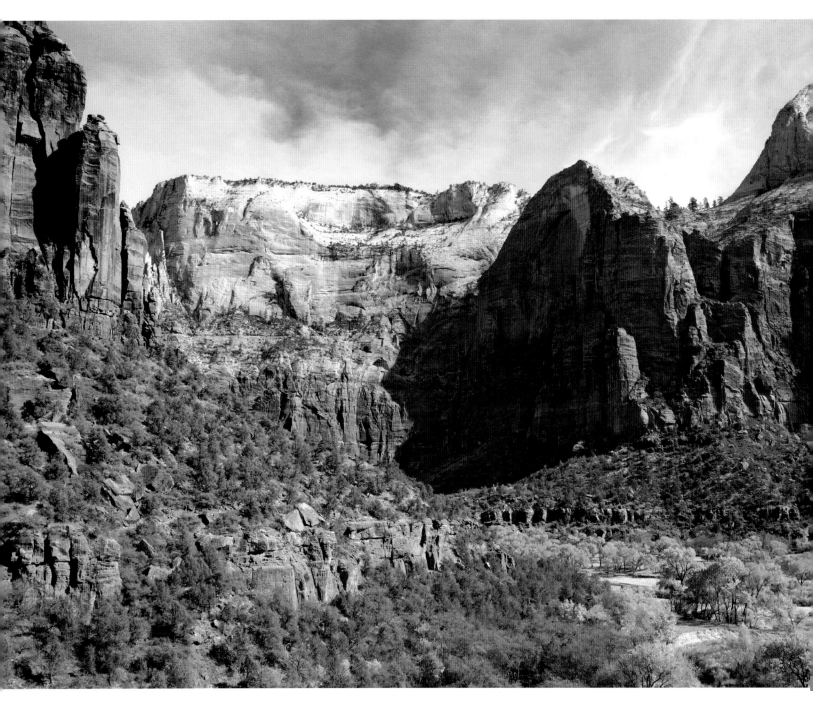

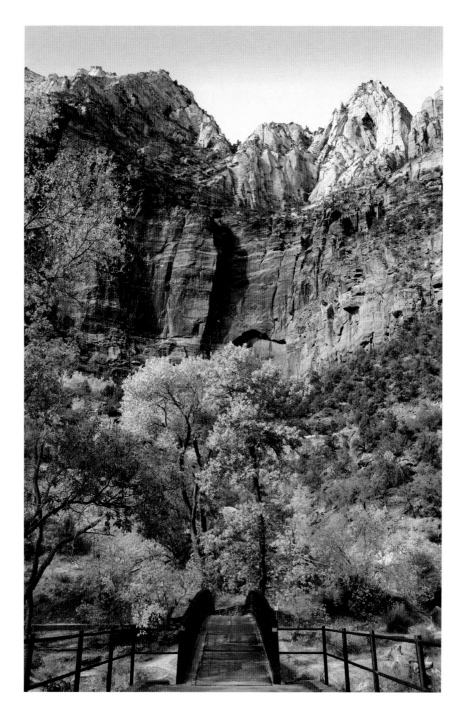

Left: Footbridge over the Virgin River leading to Emerald Pools.

JAMES RANDKLEV

Far left: Red Arch, as seen from the Emerald Pools. It is impossible to tell when most of Zion's geologic features formed, but we do know when Red Arch formed. Oliver D. Gifford had a farm around what is now the Grotto Picnic Area. It was a Sunday in 1880, so the story goes, and Oliver returned from church in Springdale to find his spring, field, and a stand of tall pines buried under tons of rock. On the cliff above soared a new arch.

JAMES RANDKLEV

Right: Shuntavi Butte from Taylor Creek in the Kolob Finger Canyons. TOM TILL

Far right: The Temples and Towers of the Virgin. J. L. Crawford was one of the last pioneer children to grow up in Zion Canyon before it became a national park. "I was born right across from [what's now] the administration building," he says, "and I had the Temples and Towers of the Virgin to look at every day. I've heard a lot of people say it's the most outstanding skyline in all the world." He stops to smile, "Pretty good place to live and be a kid."
TOM TILL

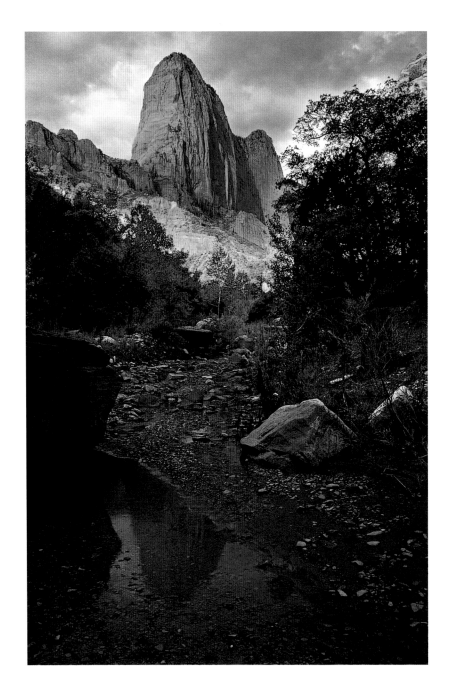

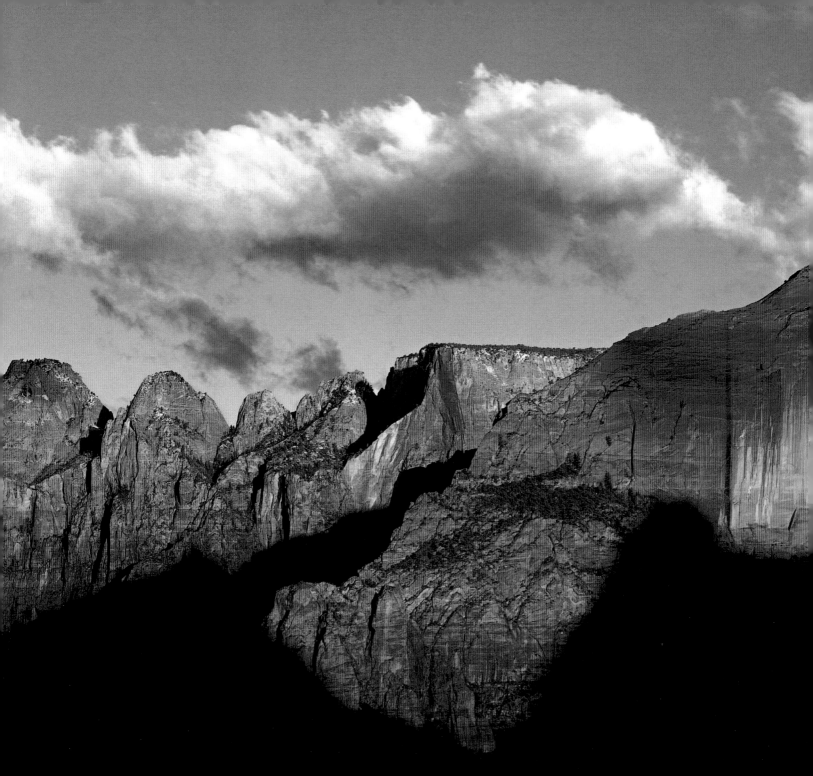

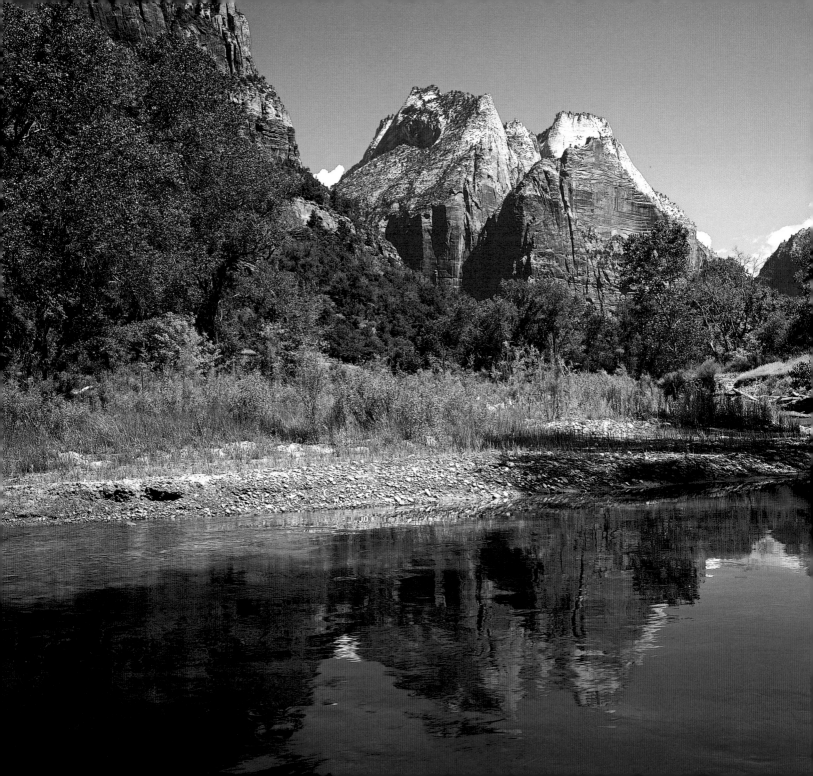

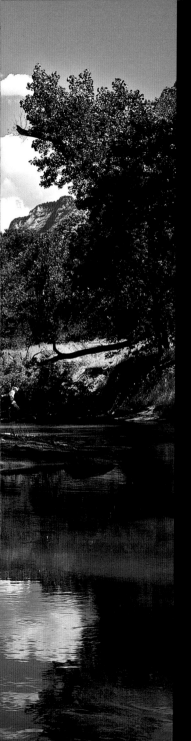

Left: Mount Majestic, The Spearhead, and Cathedral Mountain, formed of Navajo Sandstone during the Jurassic Period. Although the era is famous for its dinosaurs, no such fossils have been found in the immense prehistoric desert represented by Zion. Occasional nickel-sized tracks found preserved in sandstone were probably made by small, lizard-like creatures. JAMES RANDKLEV

Below: A small cattail marsh forms in a Virgin River backwater, offering homes to riparian wildlife such as wrens, redwing blackbirds, frogs, and ducks. TOM TILL

Right: Morning lights a clearing winter storm over the Temples and Towers of the Virgin. These days, snow rarely builds up on the canyon floor, and winter temperatures are relatively mild; but in the late 1800s and early 1900s, pioneers cut foot-thick ice blocks from canyon ponds for summer ice houses. TOM TILL

Below: A mule deer doe enjoys winter's peace. Zion National Park is open all year, although the heaviest visitation occurs during summer. Winter offers crisp, clear, uncrowded days. TOM TILL

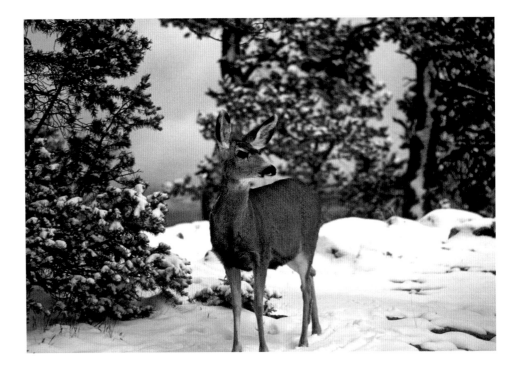

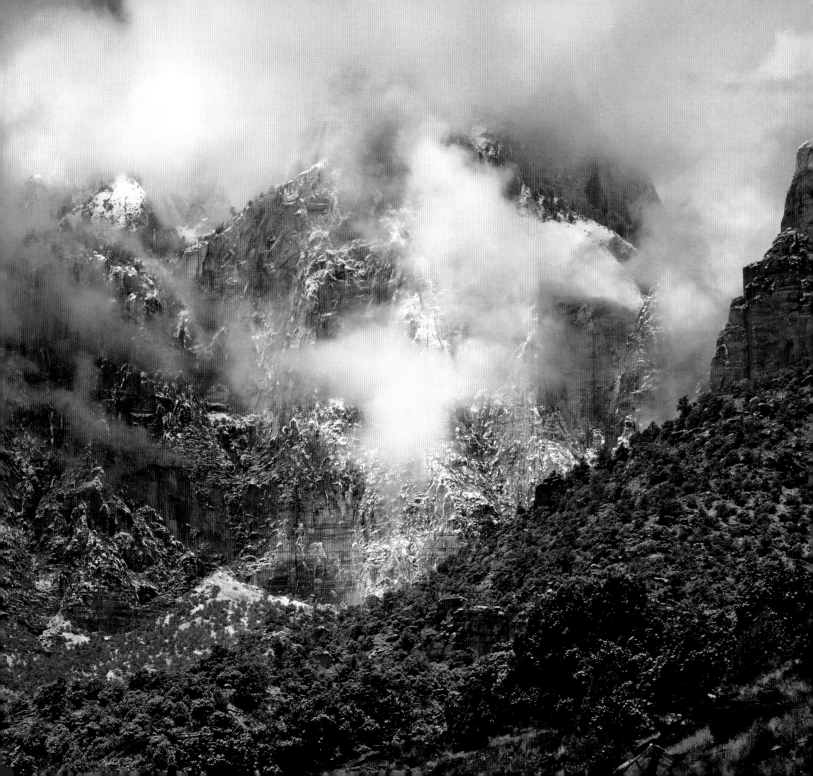

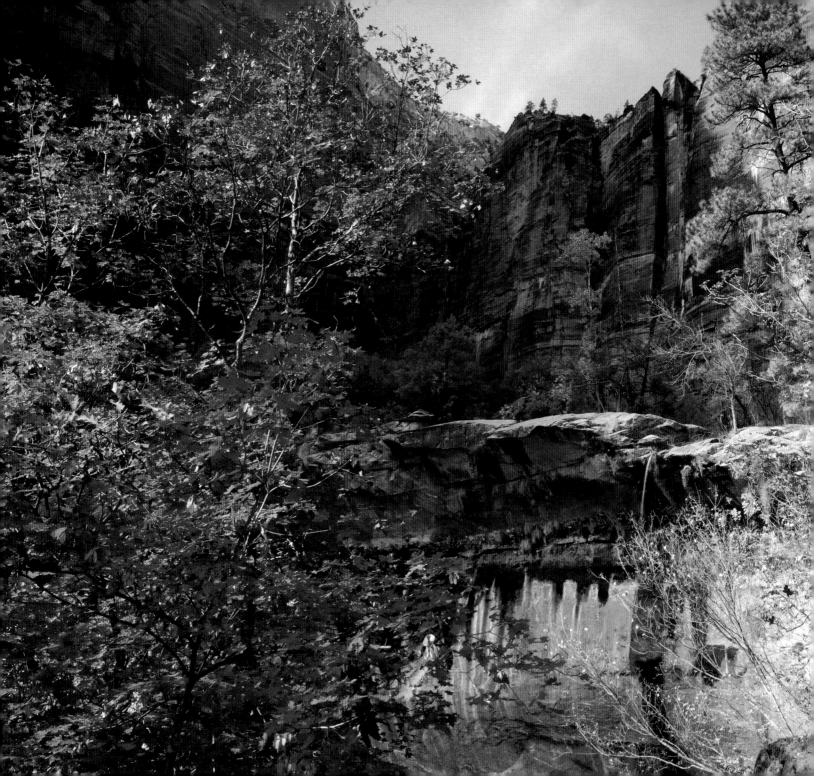

Left: By autumn, the waterfall at the Middle Emerald Pool is reduced to a trickle. During a summer monsoon, the debris-choked falls covers the entire lip—a Zion Niagara. JAMES RANDKLEV

Below: Indian paintbrush brightens a summer afternoon along the east rim. TOM TILL

...ES RANDKLEV

...landscape photographer James Randklev has photographed America for ...years, primarily with a large-format camera that provides the rich images ...ed in this volume. His brilliant and sensitive work has made him one of ...rra Club's most published photographers. His color photographs have ...red in books, periodicals, calendars, and advertising—and they have ...xhibited in the International Exhibition of Nature Photography in Evian, ... In 2003 Randklev was selected to be included in a book entitled *World's ...ndscape Photographers and the Stories Behind Their Greatest Images* by Roto ...Publications, London, England. Randklev's photography books include ...*ure's Heart: The Wilderness Days of John Muir*; *Georgia: Images of Wildness*; ...*nd Scenic Florida*; *Georgia Impressions*; *Georgia Simply Beautiful*; *Olympic ...al Park Impressions*; *Florida Impressions*; *Florida Simply Beautiful*; *Tucson ...sions*; *Arizona Impressions*; *Monterey Peninsula Impressions*; and *Bryce ...n National Park Impressions*.

...re of James Randklev's imagery can be viewed at www.JamesRandklev.com.

TOM TILL

Tom Till is one of America's most published landscape and nature photographers. Over the course of his thirty-year career, more than 50,000 of his images have appeared in print worldwide. Till is the author of more than thirty books, including *Great Ghost Towns of the West, Utah Then and Now,* and *Landscape Photography: A Practical Guide.*

In 2006, Till received the NANPA Fellow Award for achievement in nature photography, and he was inducted into the Iowa Rock and Roll Hall of Fame. Till has also received a special award from The Nature Conservancy for conservation photography.

The Tom Till Gallery in Moab, Utah, features a wide selection of Till's fine art prints, posters, and books. Till lives with wife, Marcy, in Spirit Canyon, Utah.